The Found Object in Textile Art

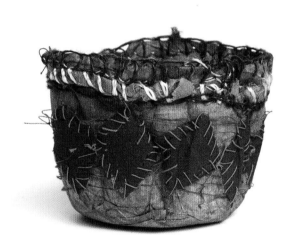

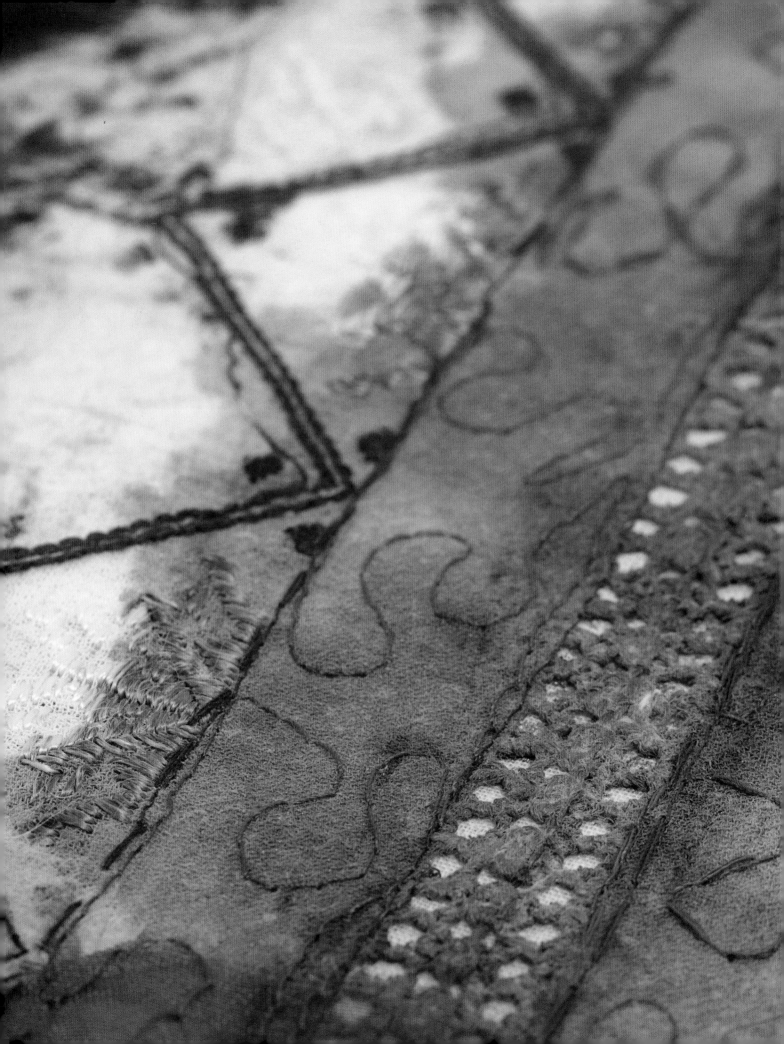

The Found Object in Textile Art

Cas Holmes

BATSFORD

First published in the United Kingdom in 2010 by

Batsford
10 Southcombe Street
London W14 0RA

An imprint of Anova Books Company Ltd

ISBN: 978 1 906388 46 1

A CIP catalogue record for this book is available from the British Library

17 16 15 14 13 12 11 10
10 9 8 7 6 5 4 3 2 1

Reproduction by Rival Colour Ltd, UK
Printed by Craft Print Ltd, Singapore

This book can be ordered direct from the publisher at the website www.anovabooks.co.uk, or try your local bookshop.

Page 1: Stitched vessel. **Page 2:** *Purple Loosestrife* (detail). The complete piece is shown on page 71. **Opposite:** *Sweeties 1/4lb.* Recycled handmade paper and French paper bag (all Cas Holmes).

Contents

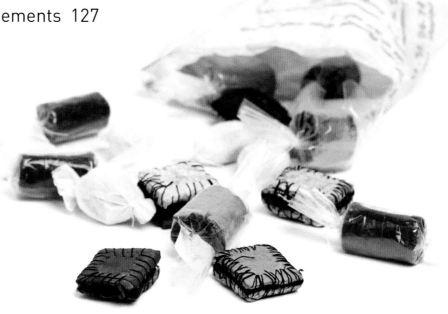

Introduction

I collect. Which artist doesn't? My collecting instinct includes books, old textiles, found images from newspapers and magazines, letters and, especially, paper discards. These precious materials are often crumpled, torn and reused. Fragmentation, erasing and layering are part of a process that marks the passing of time. I often feel like an archaeologist trying to make sense of a trail of found artefacts that I then organize and rearrange while following ideas that result in the creation of new pieces.

Those who reuse materials or use found objects as a part of the creative process do so for a variety of reasons, ranging from virtuous thrift to environmental protection. In a consumer society there is excessive wastage, so using discarded materials in textiles can reflect our political and social concerns and anxiety about global warming. The overpowering physical changes to the landscape brought about by man, through farming, building and the overuse of world resources, raise issues about our fragile relationship with the local and global environment. These issues are worthy of consideration as subject matter for the textile artist.

Equally, the use of found objects can inspire because their tactile, atmospheric and versatile qualities aid the visual artist in the creation of original statements. Robert Rauschenberg's *Bed* involved the appropriation of a traditional patchwork quilt, which was then embellished with thick paint. He referred to such works as 'combines' and went on to use a variety of media in his assemblages. Tracey Emin, in her Confessional Art pieces, layers and stitches found fabrics with writing to make quilt-like hangings that are full of meaning, but often far from the notion of 'comfort' a quilt normally conveys.

At its heart, reusing found materials is a form of alchemy. Old materials are transformed anew and using waste (and therefore cheap) materials allows the artist great freedom to take risks and experiment. Often, this transformation converts the products of a post-industrial age, such as the plastic bag and machine-printed textile, into something that is now 'one-off' or handmade through its careful working by the individual artist or craftsperson as he or she pursues his or her unique vision.

The ideas, processes and methods contained in this book are intended to act as a stimulus for the textile artist who likes to use found materials as part of his experimental working practice. Most of the materials are free; processes are low-tech, and the qualities of the materials used are celebrated as an aspect of the creative process that has become intrinsically linked to the idea of using items that might otherwise be destroyed. 'Waste not, want not' may sound a little old-fashioned, but it is also the mantra of a careful and caring creative practice, in which making and meaning have ethical considerations, carrying strong resonances for any textile maker in today's wasteful world.

When all the trees have been cut down,
When all the animals have been hunted,
When all the waters are polluted,
When all the air is unsafe to breathe,
Only then will you discover you
 cannot eat money.

Cree prophecy

Right: *Bird and Flower.* Collaged magazines and sweet wrappers, layered and stitched.
Below: Cas Holmes in the studio.

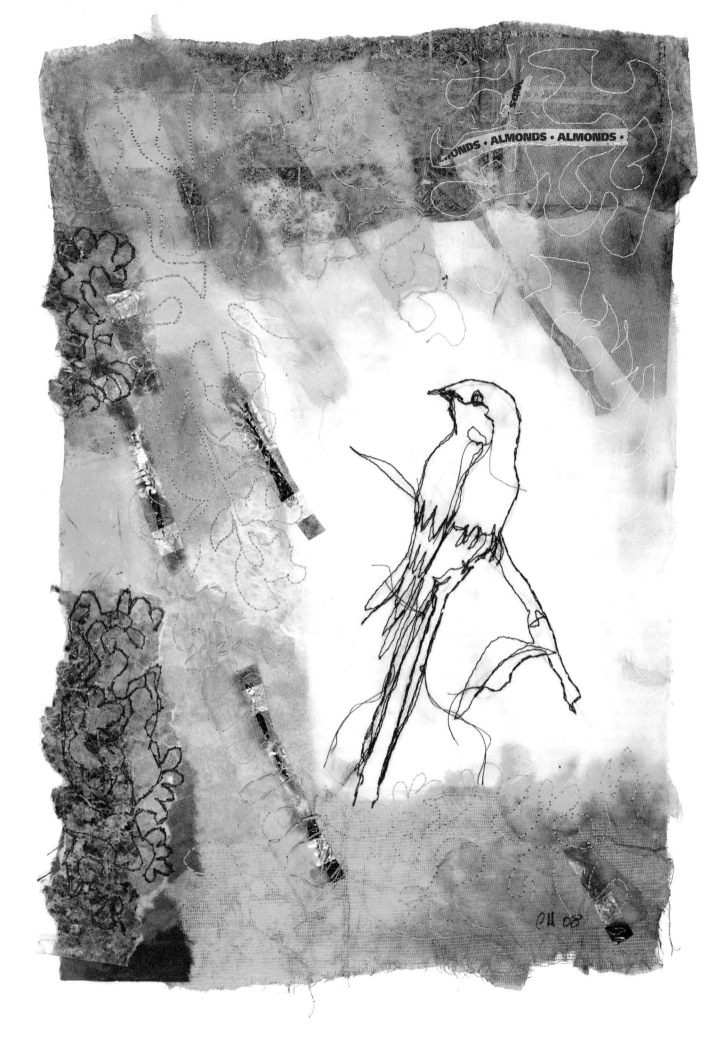

ALMONDS · ALMONDS · ALMONDS ·

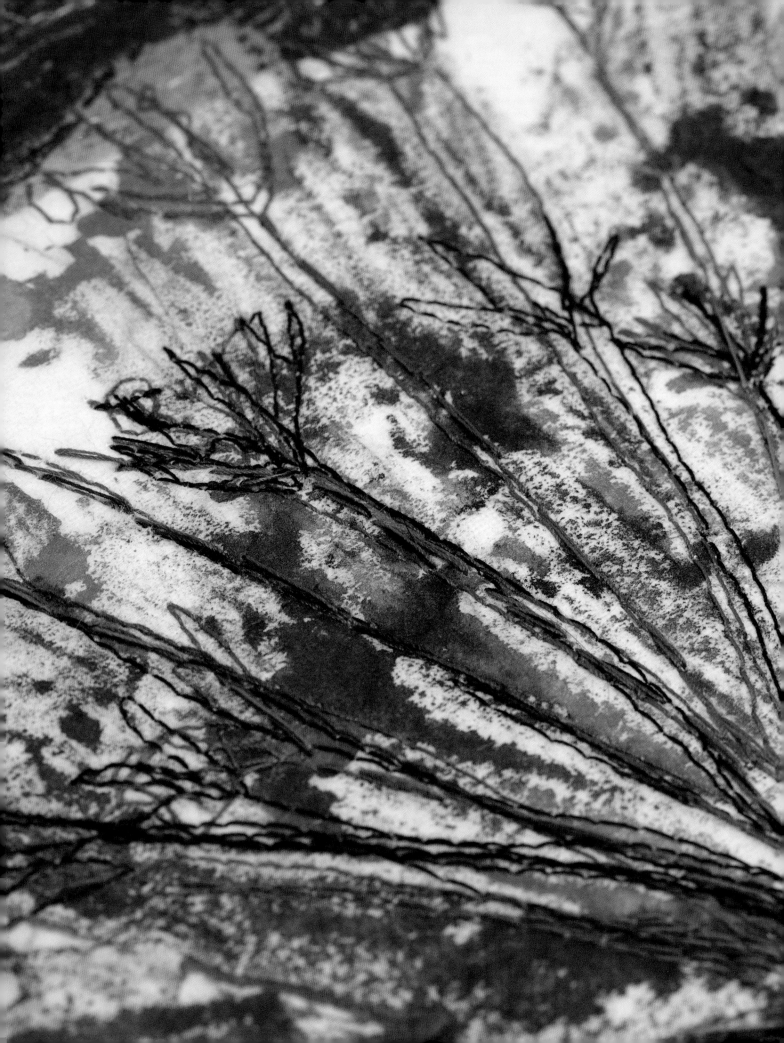

1 Beyond the surface

The processes in this section use paper and/or fabric to create new textile surfaces. Most of the materials are found or reclaimed. These finds are built up in layers and then torn and cut to create new surfaces for working. In fact, my partner, Derek, says no item of household waste is ever lost with me around, as I often find a use for it before it is placed in the bin! You never need to start with a blank canvas. Artists have always been inspired by and used found materials to create original and meaningful statements. The textile artist Michael Brennand-Wood states: 'If I can reinvent a throwaway material into something usable then that gives me pleasure.' (*The New Alchemists: Recycling*, Craftspace touring catalogue).

It is the materials that inform the process, as they often have a connection to a given place or a particular time. Old fabrics and paper therefore bring with them their own past and stories as they are transformed into new surfaces in a type of alchemy that goes 'beyond the surface'.

Most of the methods described in this book involve low-tech techniques and basic art materials, available from your local art or craft store or online supplier. Equally, much of what you will need can be found in the local DIY store or supermarket, or even under your kitchen sink. Fabric can be printed with old household emulsion paint, marked with wax crayons or stained with food colouring. You do not need a specialist studio or equipment for many of these processes and ideas. Working with a range of found papers and fabrics, you will alter their appearance with paint and dye, and then work them into layers, just as you would a painting or collage. This is then stitched with hand and machine embroidery. The action of sewing combines the layers into a unique textile, which is extremely flexible and can be used for two- or three-dimensional creations.

Left: *Umbellifer.* Red and black stitch on a printed background, with stitched lines echoing the printed marks.

Mark-making with found materials

The surface patterns of fabrics and papers can be changed with the application of simple print- and mark-making methods. In this section, we look at various paint, ink and dye media and the use of found natural and man-made objects in relation to the printed mark and your subject matter. The key is to be brave and experiment with colours, textures and imagery. You can always reuse those experiments that you feel are less successful by cutting them up and making collages, adding stitching and then printing or making further marks to create more exciting pieces. 'Rejected experiments' can also be used to add interest to the drawings and ideas you create to inform and develop your sketchbook or journal – recycle your own recycled work.

Non-traditional colouring media

In addition to the more conventional artists' paints and media, it is important to experiment and search more unusual supply sources, such as the local hardware store or supermarket or your own shed, looking for emulsion paints and stains for projects. Even the kitchen can be a source of colouring media: food colourings, tea, coffee, some vegetable juices, such as beetroot, or stains from berries can all be used for staining fabric. Food colourings can be very effective: used neat, they produce strong, vibrant colours, or they can be diluted with water for softer effects. They are particularly useful when you are working with younger age groups.

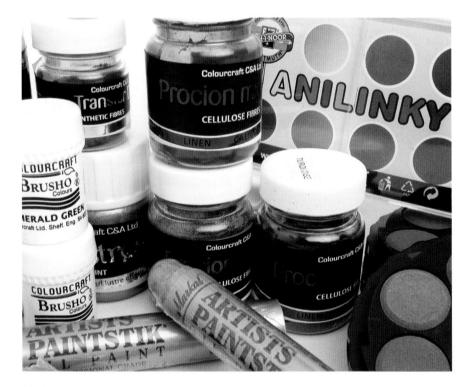

Opposite: *Remnants From Not So Ordinary Lives.* One of three panels combining textured rubbings, textiles and print using Indian woodblocks.
Left: Dyes and paints for textile and paper use.

Acrylic paints

Acrylic paints are excellent on any porous surface and can be used on fabric as well as on paper. They are readily available, come ready mixed and, once dry, are machine washable on a cool setting. Experiment with different types of acrylic-based paint, including artist's tubes, matchpots and commercial household paints left over from decorating projects. The latter can be surprisingly effective.

Fabric paints and dyes

Fabric paints come ready mixed or as a pigment you add to a base. After being painted on the fabric, they are usually fixed by ironing. There is a huge range of types. Some, such as heat-fixed silk dyes, can be painted on the fabric like an ink. Thickish paints can be used for printing, as well as diluted for painting, while more watery ones can be used for staining the fabric. Other types of pigments, such as the Brusho® watercolour range or water-based artists' inks, are an excellent source of colour for experimental work, but are not permanent. Cold-water, fibre-reactive dyes, such as the Procion range, come in powder form. They are an excellent way of changing the colours of found fabrics through immersion-dye methods. Alternatively, they can be used as a strongly coloured stain when mixed with water. You can add conventional thickeners, such as Manutex, to the dyes, which makes it easier to paint or even print them onto the fabric. I have also experimented successfully with using ordinary wallpaper paste as a thickener.

You can use dyes left over from the fabric-dyeing processes, but please note that Procion cold-water dyes, once mixed into solution with fixing agents, exhaust after three hours, and will then come away in the wash and rinse waters instead of being fixed into the fabric effectively.

Please keep in mind the permanence of the colours in your stained or dyed fabrics if you later intend to wash them or use them in further wet techniques, such as painting or printing.

Health and safety: dyes, paints and paste

This is a general guideline for all dye, paint and paste use. The dyes referred to are the Procion MX range from Colourcraft, but the same safety precautions should be used for all fibre-reactive cold-water dyes.

1. Treat all dyeing materials with great care.
2. Keep a set of utensils just for dyeing.
3. Cover all work surfaces with newspaper or polythene.
4. Wear rubber gloves and wash well after use.
5. Do not inhale the dye powder.
6. Wear a mask when handling the powder. Fibre-reactive dyes can produce asthma-like symptoms in some people and it is advisable that people with known respiratory problems do not handle them.
7. Store the dyes in containers other than those in which food and drink are stored, and clearly label them.
8. Be aware of the presence of boiling water, wet floors and corrosive substances such as bleach and washing soda.

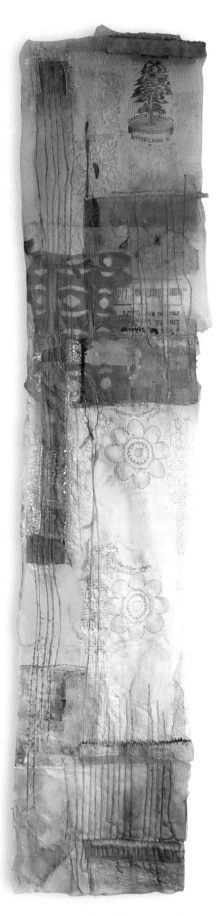

Transfer dyes

Transfer dyes use a method of printing called disperse dyeing, in which you paint dyes onto a piece of paper; allow this to dry, and then transfer the dyes onto cloth by heat and pressure. This is usually done with a domestic iron, which you protect by placing clean newsprint or greaseproof paper between the iron and the textile and paper to be ironed.

Transfer dyes are available both in liquid form and as pastels or crayons for drawing. These products are designed for use with synthetics and polycottons. Transfer dyes can also be used on cotton that has first been treated with Transfix, manufactured by Colourcraft Ltd.

Often, when making designs with transfer media for fabric, you can cut out shapes from the stained paper before ironing them onto the fabric. Save the 'waste' bits of paper and use them later to transfer their dye onto other fabrics. Decorative paper bags and papers used for wrapping flowers are often made from the industrial transfer-paper waste from printed fabrics. Experiment with ironing these on fabrics; the residue of transfer dye on the surface of the paper is often enough to produce another transfer print.

Above: Transfer print from a floral gift bag onto polycotton fabric.

Drawing media

A variety of drawing media can be used to make marks. Children's chunky wax crayons are useful for making rubbings and are a cheap alternative to Markal Paintstiks and oil pastels. In fact, they often give a better mark for frottage (rubbings). A range of felt pens and fabric wax crayons or oil pastels can be fixed with an iron. Ink pens, biros and felt pens, permanent (waterproof) and non-waterproof, give interesting marks. Quink ink gives a most wonderful blue tint when marks are made to disperse with the addition of water. It is worth experimenting with all types of mark-making media, but check their permanency first. Even some waterproof pens can run with the addition of water, dye and pasting methods, which may not be desirable if you want a permanent mark. Likewise, some acrylics and wax crayons are especially designed for school use and therefore tend to be washable!

Found materials and objects for the mark-making process

Found objects are useful both as materials and as tools for the creative process.

Surfaces

As you amass potentially useful waste fabrics and paper, note the different qualities of the surfaces to be printed or painted (fragile, heavy, transparent, opaque, coloured, patterned) and consider how these can be used. Collect a range of surface materials:

- Printed surfaces, such as old books, manuscripts, photocopies, tickets, postcards, stamps and envelopes.
- Fabric surfaces, including plain, patterned, lace and scrim.
- Textured surfaces, such as wallpaper, string, crumpled paper or packaging card.

Tear and cut fabrics and papers. Crumple them and layer them on top of one another prior to printing, painting, rubbing with crayons or mark making.

Below: A selection of papers, soap wrappers, teabags, foils and book pages.

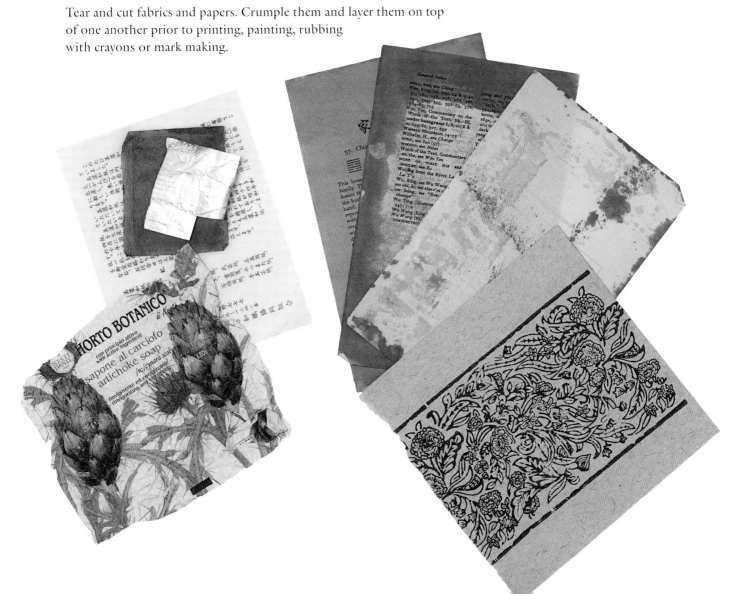

Tools for printing and marking

A range of found materials and objects can be used for printing or mark-making:

- Natural objects and plant materials, such as leaves, flowers, tree bark or shells.
- Manufactured objects, such as cotton reels, pegs, tools, nuts and bolts.
- Items that can be dipped in ink or paint and used for drawing, such as feathers, sticks and branches.

Experimenting

Be a wanderer and look around you. So many things can be turned to your artistic purpose. Create rubbings from natural forms, such as leaves or bark, or from man-made objects and surfaces. Buildings can be a wonderful source of inspiration. Look at patterns, textures and text on metal grilles, drain covers, brickwork and gravestones. Transfer crayons work well for taking rubbings and are permanent when ironed. Chunky wax crayons give excellent results and are easier to grip.

Ceramic tile spacer

Bottle top

Plastic comb

Rubber handle

Shell

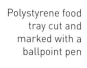

Plastic doily

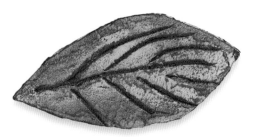

Polystyrene food tray cut and marked with a ballpoint pen

Above: Chinese fortune papers.

Consider how you can use objects and surfaces directly, as opposed to creating printing blocks or making stencils. Soft or crumpled surfaces, such as bits of clothing, can be inked up with a roller or sponge and printed. This can be done directly or you can glue fabrics and other objects to a piece of hardboard or card for stability. Pockets, cuffs and children's clothing can produce very evocative results. Find textured objects in the landscape and make prints from a leaf, a seed pod or a shell.

Domestic finds can also be a good source for inspiration and ideas: biscuits, for example, are good for simple prints and rubbings. Sponges, paper doilies, bottle tops, corks and many other items that routinely find their way into your bin can be used for printing.

Some simple print methods

Printing does not have to be complicated. Here are some simple methods.

Relief prints

Relief prints can be taken from the upstanding surfaces of printing 'blocks', such as lino cuts, woodblocks or collagraphs (see page 20). Polystyrene food trays can be drawn into with a ballpoint pen or carved for fine relief. A pencil eraser or piece of balsa wood, with shapes carefully cut out with a scalpel or marks scratched into the surface, makes a good alternative to a rubber stamp. Textured wallpapers, fabrics and natural materials make good relief prints. Machine or handstitch into waxed card from packaging or plastic sheeting, such as overhead projector film, to make a low-relief, flexible printing surface.

Below: Print and rubbing taken from textured wallpaper.

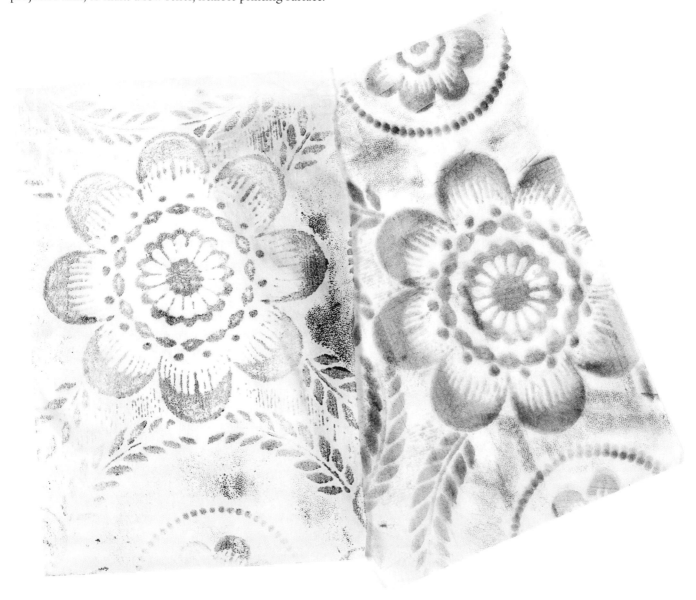

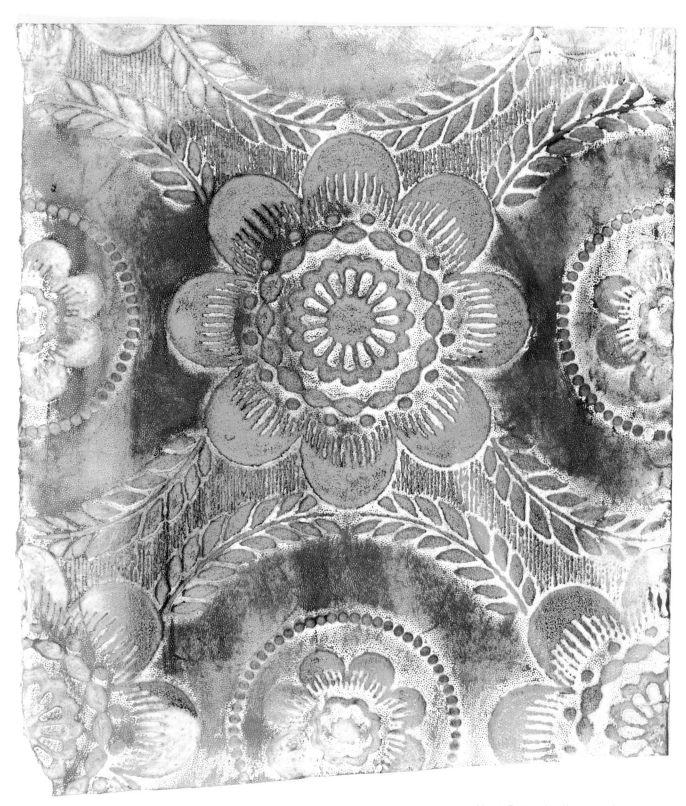

Above: Textured wallpaper makes an interesting surface for marks and prints – when finished as a printing surface, it also makes a good cover for books and boxes.

Monoprinting

This describes a print taken from a flat surface, such a plastic or glass surface, which has been painted with ink or paint. Good, flexible printing surfaces can be made from a plastic bag or bin liner, cut and taped down, old plastic folder covers or overhead projector film. You make marks on the surface of the plastic with painting media, using found drawing tools, such as sticks, sponges, paintbrushes and your fingers. The fabric or paper is laid onto the marked surface and then rubbed firmly to take a print.

Stencils

Letters cut from a glossy magazine or shapes cut out of card or plastic sheeting can make simple stencils. You can also use existing found materials, such as paper doilies, lace, old pre-cut wall stencils or torn edges from paper. Use a stiff brush, stencil brush or sponge to apply paint through your stencil. Natural materials, such as leaves and plants, make good stencils, either when used directly or with a monoprinting technique to mask an area so that the shape (a leaf, for example) remains a negative space on the painted surface.

Right: Monoprint and relief print of umbellifers in red acrylic paint.

Below: Negative monoprint of an umbellifer and a fern, taken from plants laid on plastic and inked up with dilute acrylic paint.

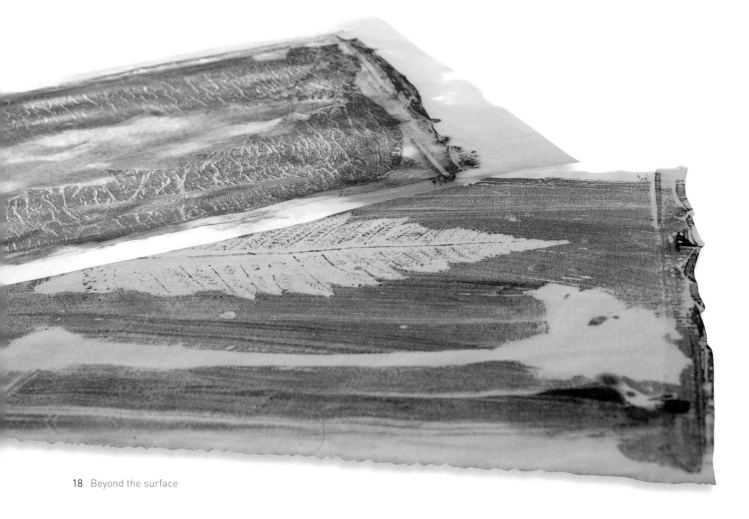

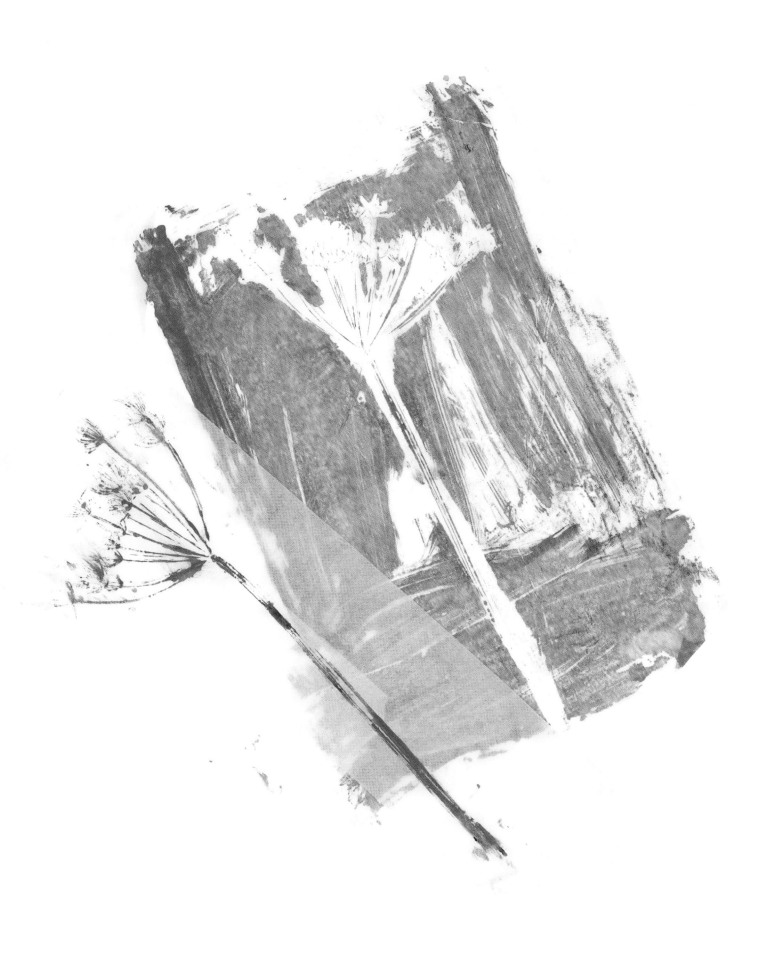

Collagraphic printing

Creating a print from a raised surface with textured objects is known as collagraphy. To make a more permanent printing block, you can attach the chosen objects to a piece of wood or firm card with waterproof wood glue (PVA) and then seal the resulting block with another layer of glue or varnish prior to use.

Double-sided carpet tape adheres to just about anything and is a good alternative to glue for making stamps or temporary blocks. Cover the entire piece of wood or card with the tape; place the objects or cut shapes on your taped surface, and they will be held firmly, ready for printing.

Plastic foam and the type of polystyrene used for wrapping around the books and compact discs you get by mail order are also useful for this process. You can draw patterns on the foam with a waterproof marker, and the foam shape can easily be cut out with scissors before being attached to the block. Lace or textured fabrics also work well as relief surfaces.

Below: Collagraphic print from a pair of children's dungarees. As you repeat the process, the prints become more defined as the fabric absorbs the painting medium.

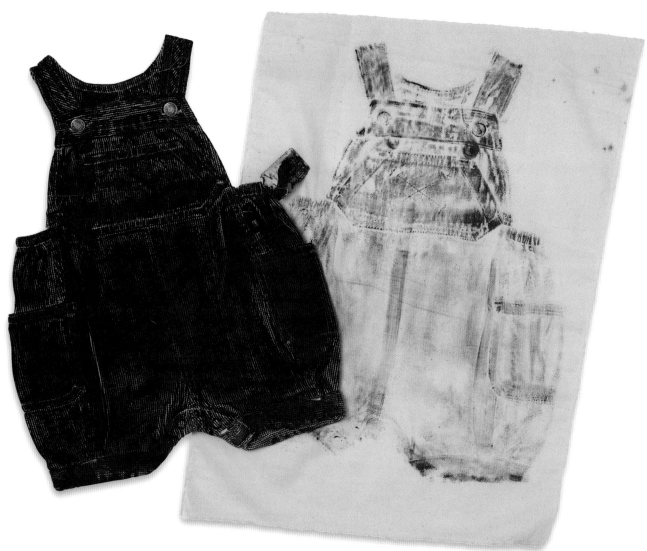

Printing with the block

To make successful prints with blocks, you ideally need a slightly soft working surface, with a bit of give to it. Instead of laying your fabrics directly on a table, floor or other hard surface, use a pad of paper or other material to produce a softer base. You can make a simple printing board by covering a large piece of wood or board with thin foam or a wool blanket and then stapling heavy-duty plastic over the top.

1. Roll some paint onto a flat piece of plastic or in a tray to get an even, thin film of paint on your print roller or brayer, and roll it onto the print block or stamp. You can also use a brush or a sponge to apply paint to the block.
2. Carefully stamp or press down on your paper or fabric. I press down on the stamp with the heel of my hand to produce a really good image.
3. Repeat the process to create a pattern. Try multiple images, placing one right beside the other for interesting effects; space and stagger them for a broken repeat, or layer images.
4. For small blocks, lay a piece of foam or sponge in a small tray to make a printing pad (cat-food trays are ideal for this). Wet the sponge and brush your paint, dye or ink onto the pad. Press the block into this and then print from the block.
5. Experiment with differing thicknesses of various printing media (paints, dyes and inks) to see what works. According to how absorbent they are, various surfaces will respond differently to the application of paint.

Above: Block printing with Indian blocks and stamps made with erasers, on various papers.

Resists

You can use a number of resists to prevent dyes or paints marking the fabric. Silk painters use a resist called gutta or wax resist. Wax candles or children's crayons offer a simple batik alternative. These can be used to draw the design on the fabric prior to painting, after which they can then be ironed away. Rice paste is used in Japanese kimono fabrics. Here, the paste is forced through a stencil or painted freehand and allowed to dry before the dye is added. Plain white flour – one cup of flour to one of water, mixed to produce a paste the consistency of pancake batter – makes a good alternative to rice-flour resist. This can be painted on fabric to form bold patterns and scratched into to give fine lines. When the paste is dry, you paint the fabric with dye. Thinned down fabric paints, Setacolour or other silk dyes are good for this process. Wait for a minimum of 24 hours before soaking the fabric in warm water for 10 minutes to remove the paste. After the fabric has dried once more, iron to fix the colour before washing the fabric again to remove any further residue of paste.

Opposite: Rust- and earth-stained fabric with free-machined alliums.
Below left: Cotton fabric that was buried in the ground with rusty objects, stained with rust marks and clay earth.
Below right: Silk fabric that was wrapped around an old tractor bolt and left to rust in salt water.

Rust prints

Rust dyeing is a surface design method in which rusty objects are used to create marks and prints on fabrics. I have used all sorts of rusty items, from old nails and screws to old pieces of farm machinery. The tools and old machine parts found when I was working as artist in residence at Cowslip Workshops (textile and quilt specialists set in an organic farm in Cornwall) gave wonderful images, reminiscent of the setting and the farm.

Natural fibres take the rust colours better than synthetic ones. You can use commercially dyed or printed fabrics for this process, but plain cottons or silks or fabrics dyed with natural dyes take rust dyeing best. When applying rusty objects to naturally dyed fabrics, the colours will change, as iron (rust) is a modifier and is used as a mordant with some natural dyes.

You can simply place rusty objects next to a piece of wet fabric and it will acquire rust patterning over time. However, salt (5 tablespoons to 8 pints/4.5 litres of water) or a 50/50 solution of white vinegar and water, or a combination of both, will speed up the rusting process, as they help to break the rust particles free from the rusty object.

1. Wrap or bind metal (iron-based) objects in your cloth, and leave for several days in the solution to leave rust marks on the surface of the fabric.
2. Alternatively, dampen your fabric with the solution and arrange, tie or smooth the fabric around the rusty object. Sprinkle with more salt and cover the 'parcel' with plastic to keep the fabric damp.
3. Check every so often for an appropriate level of rust transfer; you will notice that this transfer seems to happen faster with silk than with cotton, and happens more quickly in warm weather than cool.
4. Wash the fabric, using a washing-up liquid, soap flakes or a mild, colour-free shampoo.
5. Rinse and leave to dry.

As with dye recipes, artists have their favourite rust recipes. I normally use a simple variation of the salt solution, as suggested above; some swear by white vinegar, while others use balsamic vinegar or a mixture of both.

I have also buried the wrapped objects in the ground without any solution for several weeks to several months to see what other colours the fabric will pick up in addition to the rust.

Health and safety

Natural rust is an iron oxide, so use the same precautions as with dyeing (see page 11). It is advisable to wear gloves and a mask when working with rust, as the iron will try to bind with your haemoglobin, blocking all available sites for oxygen. The tolerance to raw iron varies from person to person, and some people can become gravely ill from too much contact with raw iron products.

Overlay and mixing dye, paint and print methods

Below are various suggestions for producing interesting results through mixing techniques. The experimental process is fun and exciting in itself. If the result is not what you wanted or expected, don't forget that it may come in useful for another work.

- Print with acrylic paints, and then dye when dry. The printed areas will show through when painted over with dye or ink.
- Apply a wax rubbing on the surface to be printed or painted with dye or ink. The wax crayons will act as a resist.
- Print and dye onto text or patterned fabrics. Explore print on torn paper and pre-dyed surfaces.
- Tie or fold papers and fabrics that have other marks on them and then dye the tied bundles.
- Print onto damp or still-wet dyed fabrics and papers to explore the soft bleed of marks.

Below: Relief- and block-printed tissues layered over dyed fabric. Quilting and machine stitch echoes the repeat motif of the print.

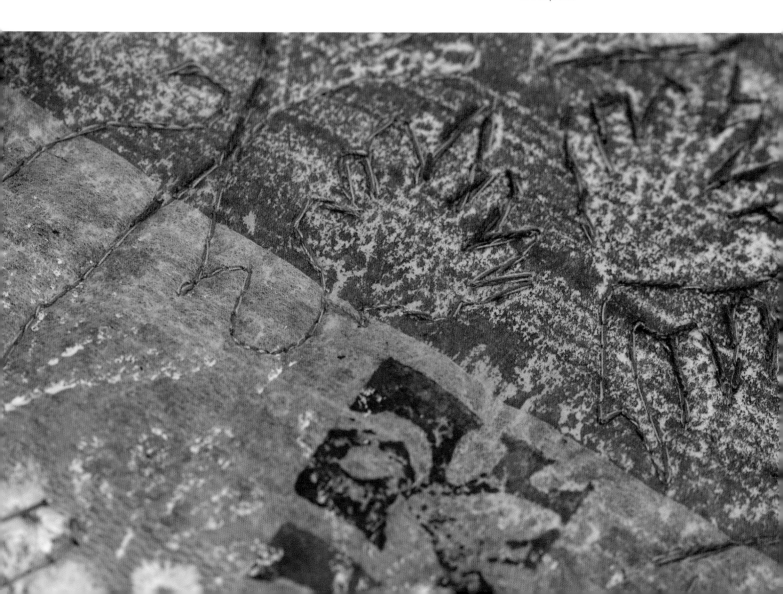

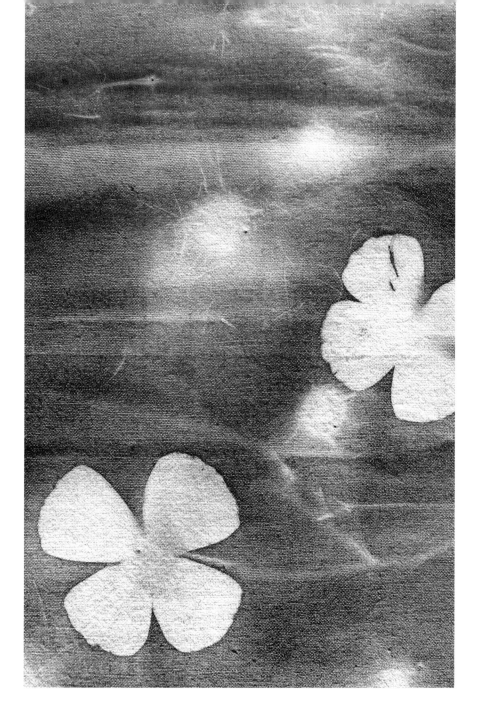

Left: Sun print with heat-fixed silk paints on cotton using plant material.

Sun printing with silk dyes and plant materials

Sun printing, or heliographic art, is a process in which the power of the sun is harnessed to produce interesting results. Heat-fixed silk textile paints are applied to fabric and, while the fabric is still wet, found objects, such as stencils, leaves or feathers, are placed on top. The fabric is then placed in the sun, and the outlines of the objects are transferred to the fabric. A range of photosensitive heat-fixed silk paints can be used for this process, including Setacolour silk paints, Soleil paints and Colourcraft transparent silk paints.

Materials and equipment

You will probably discover that you already possess most of the required materials and equipment.

- Found objects for printing: natural materials, such as leaves, flowers or feathers, or household objects, such as keys or tools, or simply pieces of paper, cut or torn into shapes and patterns.
- Cotton or silk fabric – old sheets work well, as they will not need pre-washing.
- A smooth, waterproof background board that will take pins; a polystyrene tile or a piece of cardboard covered in plastic sheeting will do the job.
- Pins
- Foam brush or spray bottle for wetting fabric
- Paintbrushes
- Heat-fixed silk paints in various colours
- Iron

Method

1. If your fabric is new, machine wash to remove sizing, and then thoroughly dry and iron smooth. Skip this step if you are using pre-washed fabric, such as old sheets.
2. Spread the fabric over the board. Wet it with clean water, using a large brush or spray bottle.
4. Using a paintbrush, apply colours with long, smooth strokes.
5. Once the entire piece of fabric is painted, quickly arrange your objects onto it, carefully pressing them tight against the fabric. Hold them in place with pins as necessary.
6. Place the fabric-covered board in a sunny spot, and watch as the sun dries the fabric and magically prints a negative image of your objects on the surface. Depending on light levels, this step can take from 15 minutes to an hour. Carefully lift the corner of one of the pinned pieces from time to time, to check progress.
7. When the fabric is dry, remove all the objects, and fix the colours by ironing gently for two to three minutes on the cotton setting.

Right: *Cow Parsley.* Sun print combined with domestic fabrics and napkins.

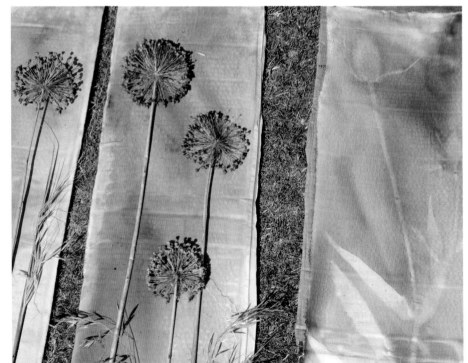

Right: Alliums gathered from West Dean Gardens pinned out for sun-printing. The outline of a thistle is shown on the right-hand print.

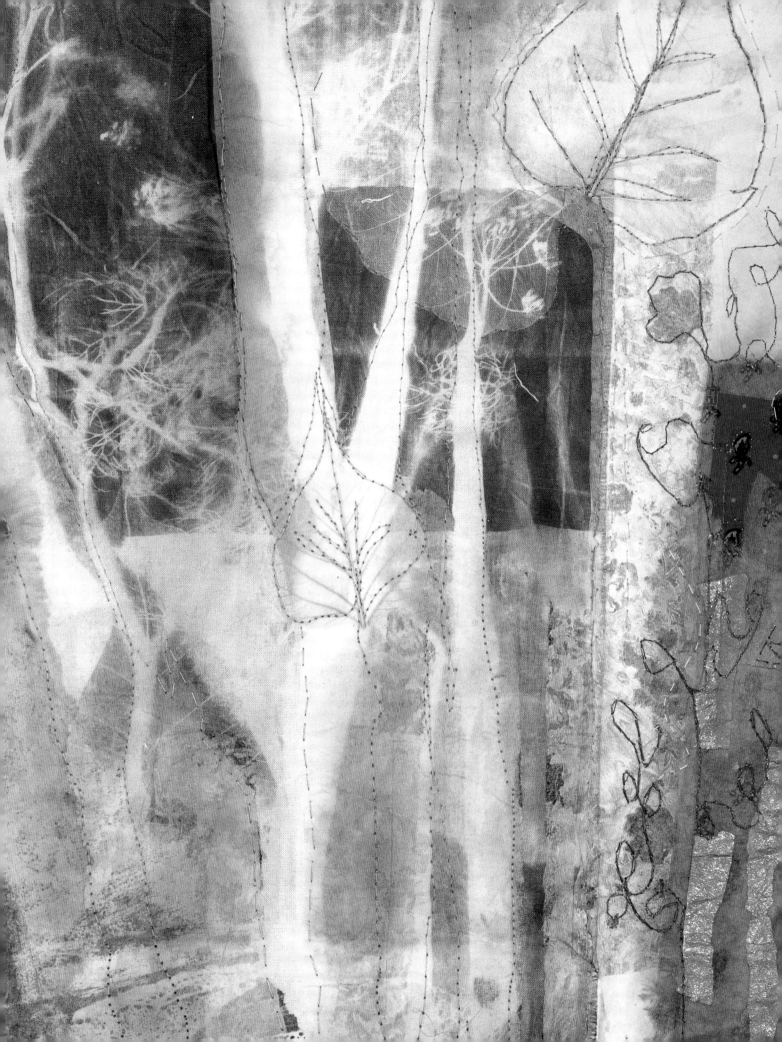

Low-tech image transfer

Found images, text or your own photographs can make a marvellous addition to the mark-making process when transferred onto fabric. You can transfer using a variety of acrylic-based media, ranging from household acrylic varnish to coloured acrylic paints designed for artists, or even household emulsion. Berol Marvin Medium, Colourcraft Superplus Medium and acrylic gel media are particularly good. You can also use Dylon Image Maker, Colourcraft Image Transfer Medium, Picture This or other proprietary transfer gels for fabrics. Just follow the manufacturer's instructions.

The methods described here use either photocopy images (produced with a black-and-white photocopier on standard photocopy paper, but not laser copier images) or inkjet prints on matt-coated printing paper, of 1440–2880dpi quality. You can also experiment with newspaper and magazines (matt-printed papers, not the glossy kind). Remember you will need to consider copyright law when you are not originating your own images, unless you use copyright-free images.

Materials and equipment

As well as your black-and-white photocopies or inkjet prints, you will also need a brush, sponge, plastic sheeting, closely woven cotton or polycotton fabric, water, printing roller (optional) and a paper towel.

Method

1. Place the fabric on the plastic sheeting.
2. Coat the photocopy image, printed side up, with a good layer of acrylic medium or paint so the image is not seen clearly. You can dilute the acrylic or paint with a third to a half of water.
3. Place the coated paper face down on the fabric and press firmly with a paper towel to ensure there are no wrinkles. You may want to roll the image down with a printing roller to ensure good contact (recommended with Image Maker), but I find a firm press with a sponge, the back of a spoon or the heel of your hand is sufficient.
4. Leave overnight or longer to dry.
5. When dry, wet the back of the image with a sponge for a few minutes and then, using your finger or the sponge, gently rub the back of the paper away to reveal the image.
6. Leave to dry; if there is still fuzz on the picture, repeat the wetting and rubbing away process.

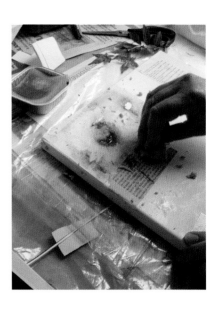

These low-tech transfer methods are only suitable for textile projects that are not going to be washed. Image quality will vary and is not intended to be perfect. You can colour the transferred image with any water-based medium, including Brusho®, inks, dyes or fabric paints.

Consider combining your transfer with other surfaces:

- Use fabrics which are already patterned or have your own prints on them.
- Overlay one transfer image onto another transfer.
- Transfer images onto stitched fabrics.

Top: Handwriting transferred onto cotton. If you want the writing the correct way round, reverse the text in your computer program.
Above: Rubbing away the back of the transfer.
Right: Inkjet print of a Norfolk beach transferred onto calico.

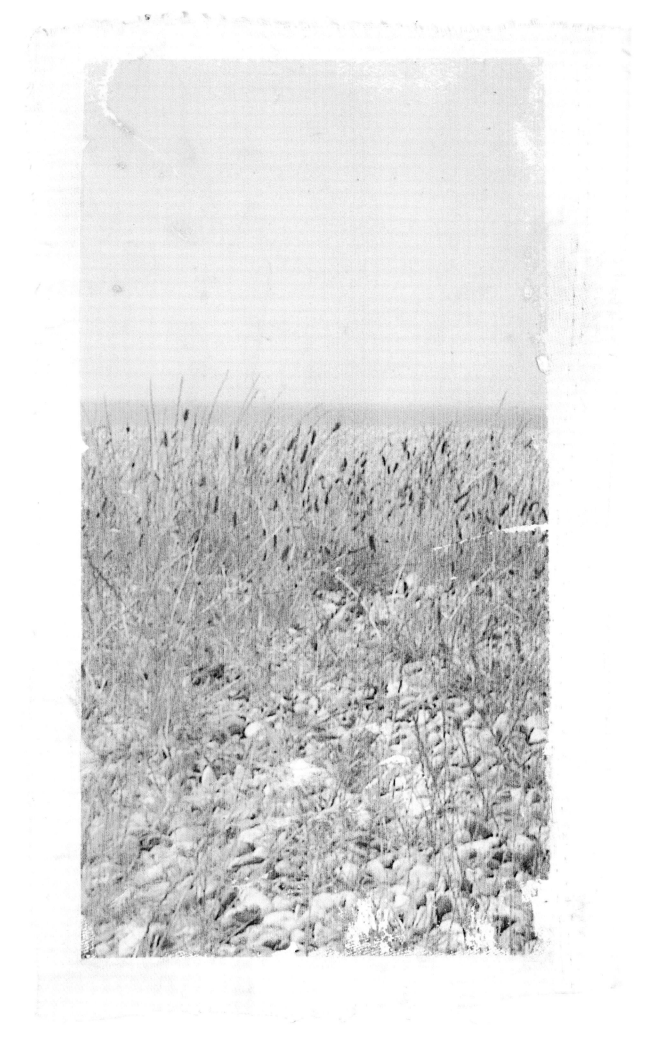

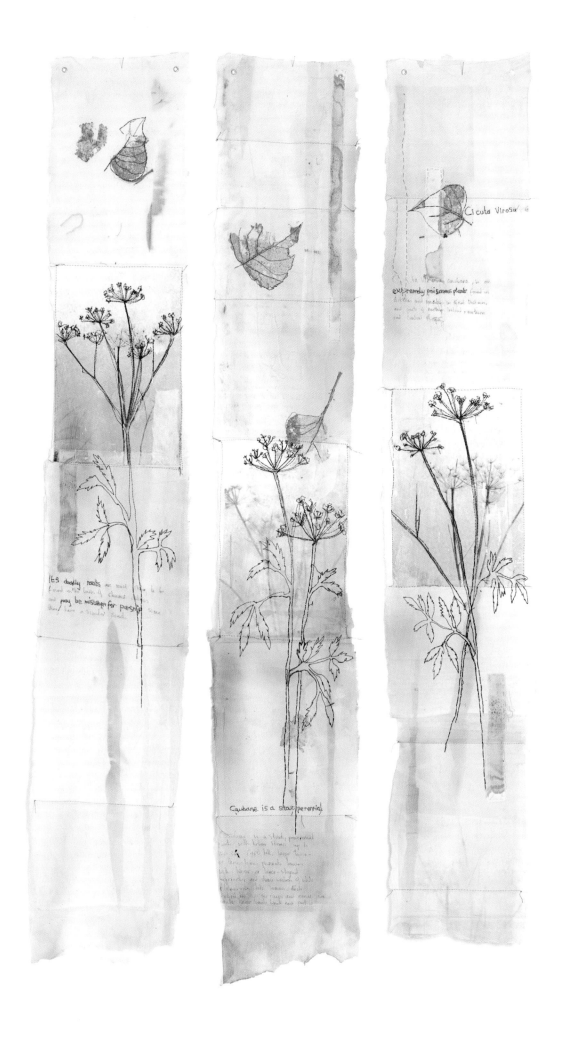

Cicuta Virosa

...ta virosa conebine ... an
extremely poisonous plants found in
ditches and suitable in Great Britain,
and parts of northern Ireland + northern
and central Europe.

ITS deadly roots are most to be
found at the back of a ditches and
may be mistaken for parsnip since
they have a similar smell

Cowbane is a stout perennial

... is a stout, perennial
plant with hollow stems up to
about 1 ... tall, large twice-
pinnate ... pinnate leaves ...
... lance-shaped
narrowing and ... umbels of white
flowers, with ... leaves, each
... ... the rays and sepals ...
... ... flowers ... each ...

Joining layers without stitching

Having collected a selection of waste papers and fabrics, printed designs and other found materials of interest, you can use these to create new surfaces for textiles, stitchery and three-dimensional projects. The printed fabrics can be used directly to add interest to patchwork, embroidery or appliqué. However, with a background in fine art and no formal training in textiles, I looked for the simplest methods of bringing these layers together. My aim was to find a method more akin to building up layers of collages in a painting than to piecing – a method that does not require the use of pins or basting stitches.

The techniques I use are simplified adaptations of textile and paper techniques explored while studying in Japan in the early eighties. To bring layered paper sheets together for screens (*byobu*) and paper windows (*shoji*), the Japanese artist uses a paste (*nori*), traditionally made with rice flour. The main difference between this method and the adapted process, other than that of training and experience, is that the paste I use is a proprietary cellulose or wallpaper paste and has been commercially bought. In addition, I mostly use found materials for the layering process, as opposed to fine Japanese papers.

The use of paper is now an established part of the creative textile process and the challenge of harnessing the translucency, texture and feel of the paper and combining these qualities with fabric is one textile artists everywhere have resolved in their own ways. Before layering paper with fabric, you can strengthen the paper by bonding an iron-on stabilizing fabric, such as Vilene's Bondaweb, to the back, or use bonding powders, or even dilute PVA or white glue. These strengthening methods are usually non-reversible; in other words, it is difficult to separate the layers later if you wish to.

The cellulose paste used to combine the layers provides a temporary adhesion that can later be stitched. You can also move things around as you progress and the layers can be separated again after they have dried. The fabric and paper combination becomes more flexible the more you handle it.

The basic process

Most papers and fabrics can be laminated or glued to one another for strength prior to stitching. Some fine oriental and specialist papers, such as conservation or lens tissues, are known as 'wet strength' papers and are a useful addition to this process. You can use many different weights of paper and fabric, even textured, the trick being to start with fairly largish pieces at the base. More absorbent papers, such as Indian khadi papers, orientals and conservation or lens tissues, will adhere to each other better than more resistant papers, such as pages from glossy magazines and coated tissues.

You can make paper more receptive to paste by crumpling it several times and then stretching it flat prior to pasting. The crumpling of paper is known as *momigami* (kneaded paper) in Japan, and is a technique used for centuries to make the strong handmade paper (*washi-gami*) more flexible. Lighter fabrics, such as muslin, lace and fine cottons, are more easily worked in with paper layers than heavier weights.

Opposite: *Cicuta virosa*. Layered tissues incorporating transferred, dyed and stitched images retain the light feel of this folding artwork.

Working on a backing of pre-washed cotton fabric or of paper, the idea is to build up layers and trap found materials, such as pressed flowers, leaves and threads, between the top and bottom layers, like a sandwich. When using found materials in this process, it is worth checking how they may respond when layered up with paste, as the dyes of some printed or painted fabrics and papers may run when wet, and unless this is desirable, you may be disappointed with the result.

Always place a surface of plastic or polythene behind the paper and fabrics to prevent your materials sticking to your work surface. The dried work can easily be removed from this backing once you have finished, because cellulose paste does not adhere to plastic.

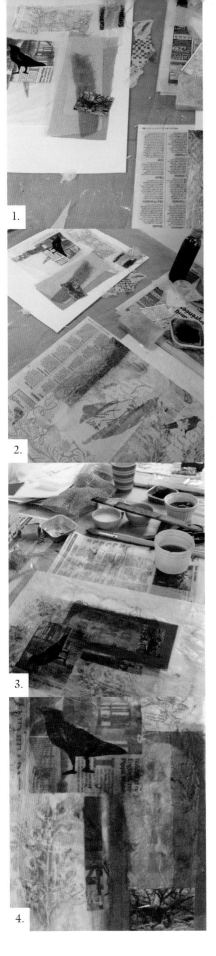

1.

2.

1. Mix cellulose paste (wallpaper paste or a non-fungicidal paste) as directed on the packet, but to around a third to a fifth of its normal strength (add three to five times as much water as suggested in the instructions). You are aiming for a thin mix, similar in consistency to double cream. All pastes vary in strength and thickness. As you practise, you will develop a sense of what 'feels right'. You may find that you need to increase the strength of paste for heavier materials.
2. Simply lay papers and fabrics on top of one another, continually brushing paste onto the layers as you go until all are completely saturated.
3. Sponge the surplus paste away and leave the layers to dry.

Some synthetic materials (such as nylons, mixed fibres and plastics) do not absorb paste as well as most natural organic fibres (cotton, linen or paper). In such cases, you may need to use a little PVA on the end of a brush as you paste, for better adhesion. As the work dries, you will see there may be some separation of layers, mostly on the layered textile-and-paper pieces rather than those made with paper alone. This separation allows for more flexibility. You can more easily cut between the layers and scrape back, or even remove, pieces. The dried layers become stiff enough to stitch without an embroidery hoop. Any colours painted on when pasting layers appear less intense than you might imagine, as dyes or paints appear darker when wet than dry, and are also dispersed into the paste as you work. You can counteract this by adding more colour as you progress with the layering process.

As an alternative to paste, you can use PVA (white craft glue) for this process of layering, mixing the glue to about a third of its normal strength by adding water. Adhesion will be stronger than with wallpaper paste, and is not reversible. The paper and fabric also lose more of their feel and, in time, become more brittle.

Right, top to bottom: 1. Selected papers and printed materials laid out before pasting. 2. Laid-out materials and pasted canvas piece in progress. 3. Layered papers pasted down. 4. Detail of the pasted sample, printed while still wet.

Further experiments

Consider how different layers may be combined:

- Place torn or cut edges against dark or light backgrounds.
- Incorporate text, manuscripts or fabric pieces.
- Insert organic material, such as small leaves or flower petals.
- Save waste threads, paper from hole punches, glitter and general inorganic found materials to sprinkle between layers.
- Consider how lighter-weight papers may be used for translucency.
- Try creasing and folding paper before gluing it down.
- Insert machined and handstitched pieces into the work.
- Use waterproof and non-waterproof pens on papers to make drawings and insert these.
- Cut up drawings and prints and reposition them in the layers.

While the layers are still wet, look at ways colour can be added:

- Consider harmonies and contrast; light and dark.
- Use dye, food colouring or inks to change white surfaces and existing found colours in the materials.
- Paint, stencil or print onto the wet surface.
- Look at opacity and translucency.
- Peel back layers and reposition them to reveal what is underneath.

Play with the composition as you work:

- Consider the shape of the piece as you layer it – cruciform, long, wide, or a series of small shapes.
- Look at different lines – horizontal/vertical, wavy/straight, thick/thin.
- Explore shapes – repeats, symmetrical/asymmetrical, organic/geometric.

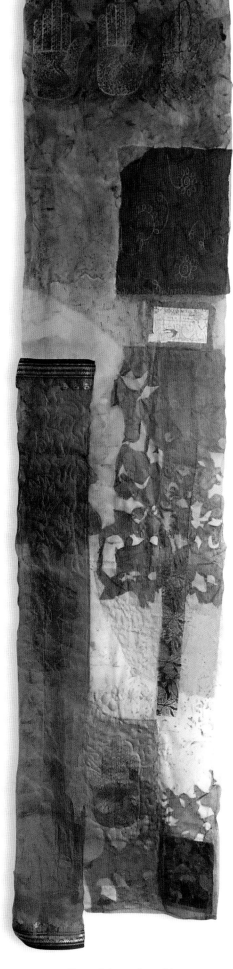

Above: *Remnants From Not So Ordinary Lives.* One of three panels combining layered papers and fabrics from India. On the right-hand side of the panel, lace-cut paper is laid between cloth and a top sheet of a lighter tissue paper.

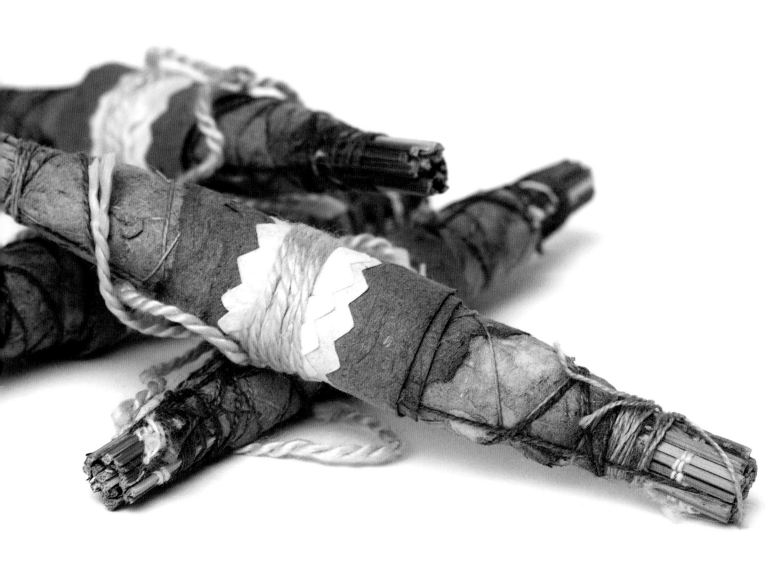

Above: *Small Bundles.* Bamboo splints wrapped in dyed and layered paper that was collected in shopping malls in Japan.
Right: *Stitched Vessels.* Printed and dyed papers pasted into small yoghurt and fruit pots, which were used as moulds. Stitching was used to add interesting detail and help the pots hold their shape.

Working three-dimensionally

Much of the layering described so far has been flat or two-dimensional. When dry, however, these new fabrics can be cut up and stitched to make three-dimensional shapes. It is worth experimenting during the wet stage with the use of moulds and found objects as surfaces on which to layer, rather like the papier-mâché technique. This is great way of using 'waste' pieces from other experiments. The paste should be a little stronger for this purpose: half to full strength, depending on the absorbency of your paper. The success of your project requires you to use stronger papers, such as abaca or mulberry paper.

As with flat surfaces, unless the found object is to remain part of the textile work (if you are reusing an old box, for example), you will need to protect the object from the paste and also make it easy to remove or cut away from the surface. Plastic, glass or china moulds can be coated with petroleum jelly. For other objects, such as unvarnished wooden forms or plaster moulds, you can use clingfilm.

Process

Tear the tissues and papers into smaller pieces and cut up or tear any other materials you want to introduce into the layers (scrim, lace, leaves or threads, for example). Layer these items on the mould, using the same process as for the flat method. You may need to add a little at a time and allow sections to dry between layers, depending on the complexity of your shape. Add colour (ink, dye or paint), printed materials and small findings as you go.

When the layers are completely dry, remove the shape from the mould. Some forms may need to be carefully cut and the edges taped together. You can then paste and layer over the joints (alternatively, stitch the layers together). You can now embellish this further with stitch, print and other mark-making techniques.

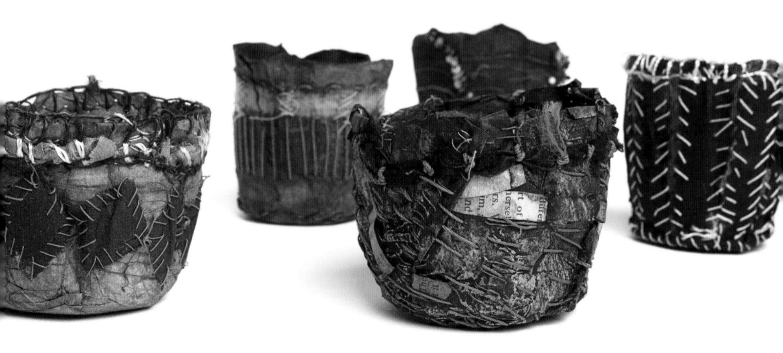

Destroying and remaking

The next stage in the process of building new textile surfaces could equally be termed 'revealing and concealing'. Once you have built up interesting surfaces, these can now either be treated as fabrics for working into or they can be cut, torn, reworked and further layered with the paste. You can become an archaeologist, revealing what lies underneath by cutting through with scissors or a scalpel, or you can use those new-found surfaces as pieces of textile that can be further painted, machined and handstitched or used for patching and quilting. This process is not linear and, even after stitching pieces, you can cut them up into smaller sections and reuse them in the paste-layering process or print them back onto the surfaces, as described earlier in this chapter.

Colour

Note how the colours in your found materials relate to the work as you build the layers. Colour not only suggests the content of a piece of work, such as a sunny landscape, but can also express a mood or suggest an emotion. Warm sunny colours, cool watery colours – we respond emotionally. Consider contrasts, neutrals, and black and white. Move away from your usual colour palette and play with new combinations of colour.

Collect and use

Continue to collect and incorporate new textures:

- Envelopes, brown paper, packing materials, magazines.
- Wrapping paper, decorative paper, tissues.
- Handmade and hand-dyed paper.
- Fabrics with patterns and different textures.
- Torn/cut edges against a dark background.

Deconstruction and reconstruction

There is so much you can do to your layered surface:

- Break down the surfaces and reassemble, to reveal hidden text, images and patterns.
- Cut up and work dry pieces back into the wet layering process.
- Roll back, crease, scrape and tear the surface.
- Rework on top of the layers with print, paint, dye.
- Pleat, crease and fold surfaces.
- Machine and handstitch sections.
- Consider using traditional techniques, such as patchwork, appliqué, mola or smocking.
- Stitch in *momigami* (kneaded paper) or other types of distressed papers and materials.

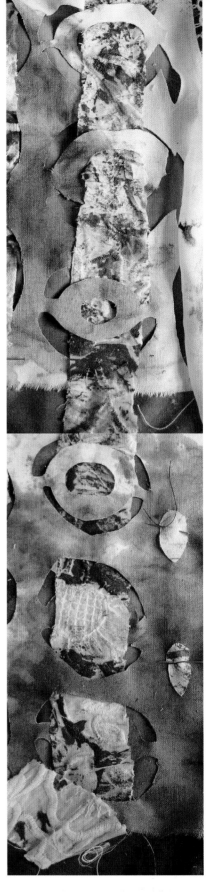

Above: Printed and dyed textiles pinned for sewing (Anne Kelly).

Momigami

Momigami, or kneaded paper, can be added at the 'destroying and remaking' stage. Olive oil, baby oil or even cooking oil can be used for this process. The oil makes it easier to work the paper and affects its character and surface, after which it can then be machined or handstitched into your layers. The secret is to use just a little oil, or your paper could end up looking as if it has been used to wrap fish and chips!

The basic process

1. Rub a little oil into the palms of your hands – just enough so you can feel that it is there.
2. Crumple and stretch the paper (this is described in more detail on page 38).
3. Continue the process, adding more oil to your hands as and when needed; heavier papers will need a little more working.
4. When the paper feels flexible and almost cloth-like, it is ready for use.
5. Hand or machine stitch the paper into your layers. Leave the stitched paper for several days between layers of paper towel to absorb excess oil, under a board weighted with books.
6. If you want a slightly flatter surface, iron between layers of newsprint, greaseproof paper or old cotton fabric. Ironing also helps to remove remaining excess oil.

An interesting alternative to crumpling the paper by hand is to start the crumpling process as above, but then wrap the paper around a plastic tube or ruler and push it gently down the tube. Lighter-weight papers work easily; heavier ones may need to be bound with thread. You can also use this method on dampened paper or fabric. Before unrolling, paint the scrunched paper with ink or dye; as it dries on the tube, this will leave an interesting pattern.

Acrylic momigami

An alternative momigami process is to use diluted acrylic wax or other acrylic medium, Marvin medium and paints for this process. You will get varying results, producing a paper that is more leathery and stronger, but which will not have quite the same fabric-like feel as the oil-based momigami.

1. Lay out a plastic sheet to work on.
2. Dilute the Marvin medium or acrylic medium to a half to a quarter of its normal strength, adding 1–3 parts water.
3. Coat the paper on both sides with the diluted medium, using a brush or sponge.
4. Sponge the excess off so the paper is not dripping with medium.
5. Either work the wet paper between your hands, as with the oil-based process, or allow the paper to dry and then crumple it.
6. Leave the paper to dry on the plastic sheet, or hang it up on a line.

The momigami kneading method

You can use oil or an acrylic medium with this kneading process. Take a sheet of paper and fold the four corners into the centre. Crumple the paper gently into a loose ball and then gradually pack it into a tighter ball, turning it round and round, and squeezing and wrinkling the sheet carefully but firmly. The sheet is then unfolded and the wrinkling and crumpling repeated.

After three to four minutes of this, open the paper up, grasp the near corner and rub between your palms, paper rubbing against paper. Then lay the entire sheet on a flat surface and stretch it slightly by applying pressure with your hands in an outward direction toward the sides and corners. This crumpling, rubbing and stretching process may then be repeated.

Some papers will behave better than others. You will need to do the stretching and crumpling less for the wet acrylic process than for the dry process with oil. In Japan, the traditional process, while similar, uses a very different medium to the oil for coating and strengthening the paper. The Japanese technique employs a starch paste made from *konnyaku* (pronounced 'kohneeyahkoo'). I discovered its use for strengthening paper while studying and working in the small paper-making village of Kurotani in Japan in the mid 1980s. In *Washi: The World of Japanese Paper*, Sukey Hughes writes:

> Konnyaku is a tuberous root of the devil's tongue plant of the Arum genus, the starch of which is used as a mucilage... The application of konnyaku makes paper strong and flexible enough to withstand the

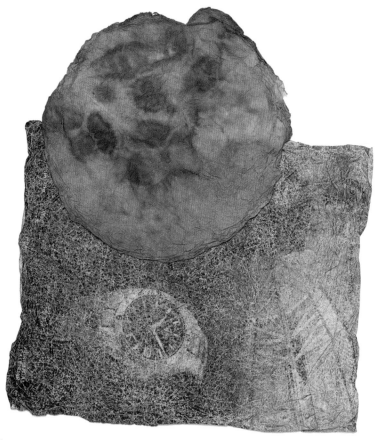

Above: Momigami: blue-stained coffee filter and magazine page.
Below: Various momigami papers: magazines, wrapping papers and Indian papers.

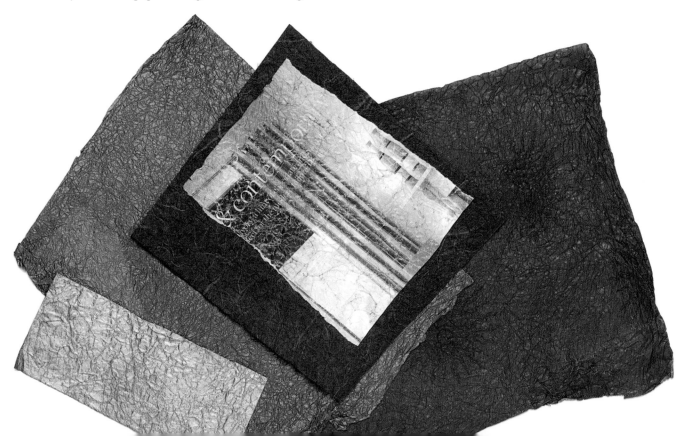

rubbing and wrinkling process; both treatments, in turn, render momigami [wrinkled, kneaded paper] much stronger, softer, and more flexible than untreated paper. Because the mucilage coats the paper's pores, the sheet becomes not only wind and water-resistant, but the paper's natural heat-retention qualities are enhanced; and yet the paper still breathes.

A treatment of konnyaku imparts strength, in particular wet strength, so that when the paper is immersed in a dye bath, for instance, the sheet stays strong and completely intact. It was used to make *kamiko*, a form of paper clothing, as well as for small objects such as purses or book covers.

In the making of your momigami, experiment with different papers, magazines, brown parcel paper, old animal feed or potato sacks and long-fibred eastern paper, all of which can work well. Consider how the paper surface starts to remind you of other surfaces, such as aged and faded fabric, peeling doors and walls or old documents.

Paper-lace momigami

The final way I use this kneading technique is to make 'lace-like papers'. This usually works best with patterned serviettes or napkins saved from meals. The serviettes are made with fine paper and you fold them to form between two and eight layered paper pieces, depending on the thickness you want. Fewer layers will result in a more lace-like appearance after working; more layers give you a much more substantial and almost 'felt-like' texture.

Machine-stitch patterns into the folded paper, ensuring that the machined lines cross over to form a grid, which can be regular or irregular. When the stitching is complete, wet the paper and rub it in your hands quite forcefully until holes appear between the grid lines. This effectively wears away the paper and you can continue for as long as you like, to achieve more holes or a lace-like appearance. Iron the paper flat when it is nearly dry.

These lacy papers can be used to create an added surface for your textile work. They can be dyed and coloured before use and ironed to flatten them, if you wish. Stitched onto the layers of fabric, they create interesting textural contrasts. Alternatively, they can be inserted into the wet layering processes described earlier (see page 31–34).

Above: Worn and stitched momigami napkins.

Make, break and rejoin

The new textile surfaces created through the layering process can be treated like any other fabric and worked with in much the same way. The dried paste may make textiles feel a little stiff, but this eases with handling. This relative stiffness has the advantage of making free-motion machining easier on the sewing machine. When working on a project, I often take the discards and paste them together. When these are dry, they can be heavily machined to create a rich textile surface, which can then be cut up and used like any other fabric.

Consider how you may alter this new surface. You could further develop your ideas by cutting the piece into smaller sections, creating seams and applying a variety of textile approaches:

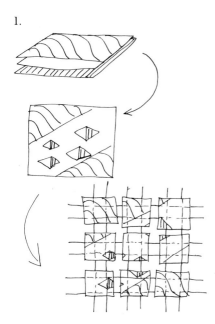

1.

- Vary the angles and widths of pieces you cut out and rejoin (1).
- Fabric and papers could have irregular and frayed edges.
- Use beads, wrapped thread, skewers, willow – all kinds of decorative inserts and attachments (2).
- Create lines and texture by stitching in seams, pulling threads to ripple the surface and exploring smocking.
- Use repeats and work to different types of grid, such as those found in a quilt or patchwork patterns.
- Layer the pieces with stitch and then cut spaces out of them, like a form of reverse mola, and reinsert the cut-outs.
- Consider cutting the layers up into sections, working with machine sewing and then joining the pieces back together; old dress patterns, patchwork piecing and quilt designs can make good starting points (3).
- Consider creating modular pieces, working in a series of separate panels linked by their theme.

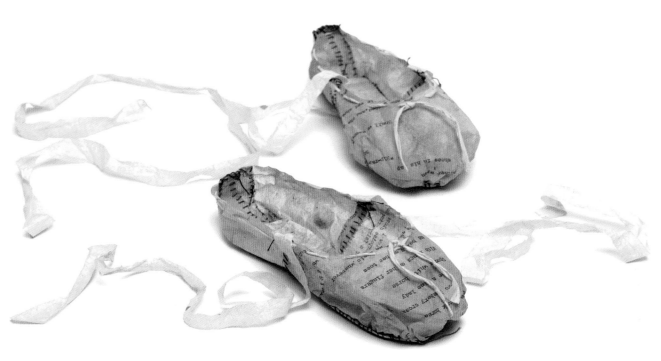

2.

3.

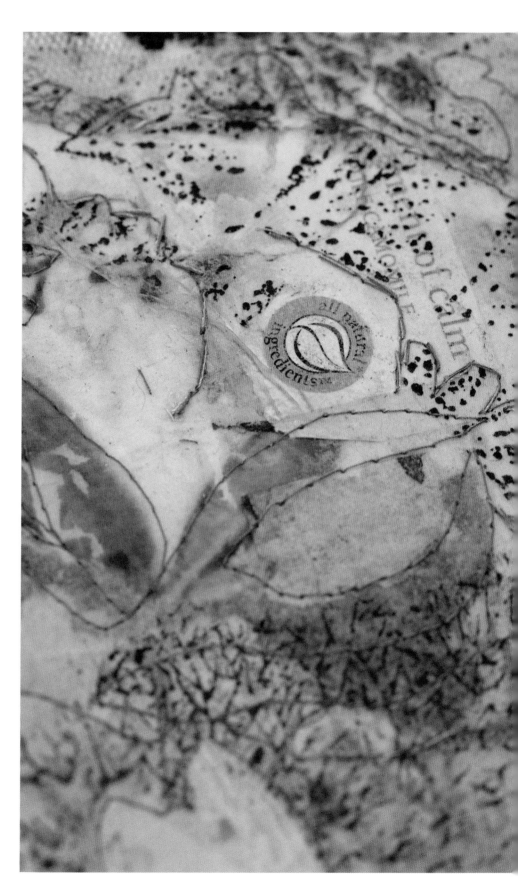

Left: *Ballet Shoes. A* pattern was taken from an original shoe, cut out in paper and joined with stitch.
Right: Layered and printed papers with free-machine embroidery and handstitch.

Stitch possibilities

Stitching is a technical necessity to hold layers together, but the textile artist can employ a wide variety of stitches, using both machine and handstitching. When using stitch, consider the type of mark you make and with what material. A sewn line on the machine is usually not reversible, as it will leave its own palimpsest, a 'shadow' of what went before. This can contribute towards the creation of apparently aged surfaces, giving a sense of wear.

Be adventurous and look beyond your usual threads. Electrical wire, paper thread or raffia and Indian cotton threads can be used for stitching. A stapler can create an interesting row of marks. Consider each mark you make as a line, not only to hold the work, but to add a visible element of drawing.

Machine stitching

Experiment with different possibilities:

- Machine-stitch sections before cutting them up and replanning them.
- Cut up existing pieces and insert them into new sections.
- Fold and crease work before stitching and make raised seams with machining.
- Combine normal stitching with other methods, such as machining on water-soluble fabric or plastics and using non-fraying materials and synthetics.
- Leave long thread ends when machining and stitch these back into the fabric for a different type of mark.
- Place two threads into the needle prior to machining or stitching by hand.
- With no thread in the machine, punch holes into surfaces with the machine needle to leave a pattern or create wear in the fabric.

Below: *Journal.* Areas cut away to reveal roofing felt are held with straight stitch.

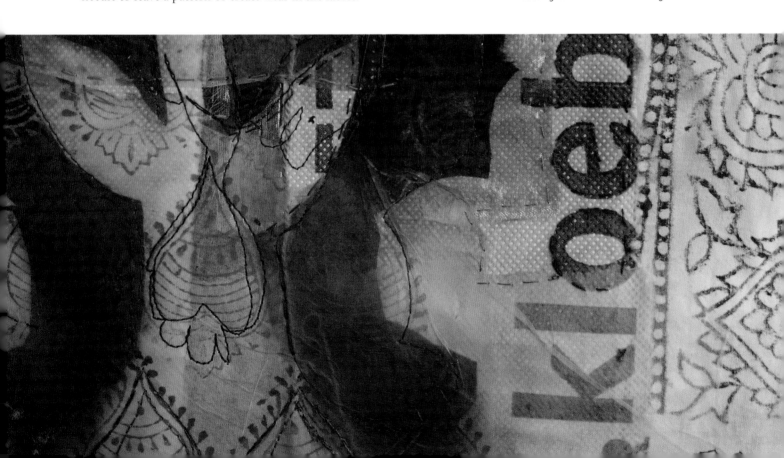

Handstitching

Basic handstitch techniques might include:

- Various linear stitches, such as running stitch, backstitch, split stitch, kantha and sashiko.
- Couching (useful to hold thicker threads, wire and rope in place).
- Various embroidery stitches, to add as a decorative or featured element, including cross stitch, French knots, chain stitch, satin stitch, seeding, herringbone or blanket stitches.

Working with stitch

- Use more than one thread in the needle.
- Try stitching with raffia, hair, tape or cut-up tights.
- Work the stitches close together or far apart and vary the dimensions of the stitches.
- Work stitches on top of one another, for density.
- Try wrapping and overstitching.
- Stitch down small scraps of waste material.
- Bring knots through to the front.
- Leave threads hanging.
- Stitch straight or curved lines, or create patterns.
- Take a single stitch, such as a simple straight stitch, and see how far you can go with it.

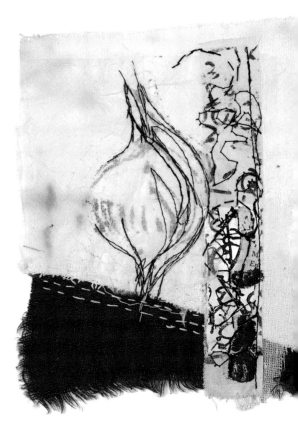

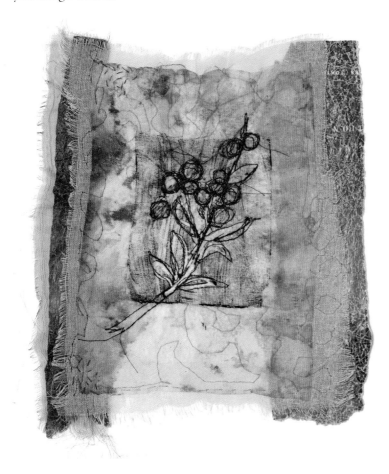

Above: *Red Onion.* Free-machine and handstitch add interest to the onion and text print.
Left: *Flora: Wild Berries.* Free-machine stitching gives added texture to the monoprint of autumn berries in this collage of fabric and paper. Threads are left hanging for textural interest.

Stitch as a line – a little more on mark-making with stitch

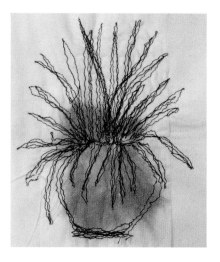

Above: Stitched line drawing of a plant in a pot (Helga Widmann).

A drawing is simply a line going for a walk.
Paul Klee (1879–1940)

All drawing starts with a mark or a line. The same applies to stitches: the sewn thread can be used to define shapes and can be used as a primary mark-making technique in its own right. Look at textural stitches as well as decorative ones and how they could reflect the content of the piece. Stitching, whether by machine or hand, should be considered as part of the 'show', deliberately exploited to add to the texture of the cloth. The mechanics of stitching are intrinsic to the making of the piece and should relate to the found materials used, and the mood or feeling of the work.

Consider how you can improve the kind of textural marks you can make, both by hand and machine. Trained in fine art, I find that drawing – the marks made with a pen or pencil – informs the way I stitch. Attending classes in drawing can aid the textile artist in developing drawing and observational skills, as well as helping to develop a more considered approach to mark-making. A useful exercise, prior to using your machine to stitch a line, is to set up some still-life objects or plants on a table and then try to draw them without taking your pen or pencil off the paper. This will help with your hand-and-eye co-ordination when you try to draw with a continuous line as part of the free-machine stitch process. When learning to stitch, it is preferable not to aim for perfection of form to the detriment of rhythm and movement. Mistakes and reworking can contribute to the creation of more expressive work, with richer surfaces as the result.

Above: Stitching a continuous line – vermicelli – from the back of a work, following a floral pattern.
Opposite, top and middle: Stitch following the line of a drawing from the back of the fabric, adding line and detail to the image of the cow parsley on the front.
Opposite, bottom: Flower image stitched through from a napkin on the back of the sample to the face of the work.

Making marks with stitches

When using stitch, consider how the mark can change the physical or visual texture of your surface or can be used as a line of drawing. The methods described below apply equally to machine and handstitching.

- Use stitch as a kind of 'shading' and feel free to borrow or adapt techniques. For example, kantha, a stitch that evolved in Eastern India, is used in embroideries to tell stories or depict nature. Traditionally, this simple darning stitch is worked through layers of fine fabric – such as old saris – and, in doing so, creates ripples in the surface of the fabric. Adapt its use for working through your layers.
- Consider creating continuous pattern. Vermicelli is a meandering stitch that wiggles in and out and backwards and forwards without the stitching crossing over itself. It can either be worked in lines over part of a piece or cover whole areas of cloth. It can be very effective when the stitch is worked in a contrasting colour to the background fabric.

- Another approach is to adapt the pattern-making methods used in *sashiko*, a Japanese running stitch used to layer fabrics for warmth. Contrasting white thread is usually stitched with neat measured lines into intricate traditional patterns, using a continuous line of running stitch representing elements from nature. This is a good stitch with which to create geometric interest in layered paper and fabrics. Many sashiko designs lend themselves to machining. You can mark a suitable design on the back of the work and, using a heavier contrasting thread in the bobbin, machine the pattern through to the front.

- Take this idea further by using found fabrics with interesting patterns on them and attaching them to the reverse of your work. Machine the piece from the reverse so that the pattern you follow meanders on the front of the fabric-and-paper layers. Add wadding between the layers to create a quilted surface, if desired.

- Make a drawing on the back and stitch from the wrong side (without looking) to vary your mark. You can trace an image from a flat found object (perhaps a leaf, a pattern from a wall or a rubbing) onto a lightweight fabric prior to pinning and then machining or handstitching.

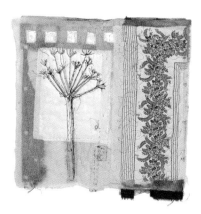

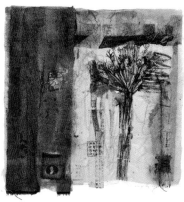

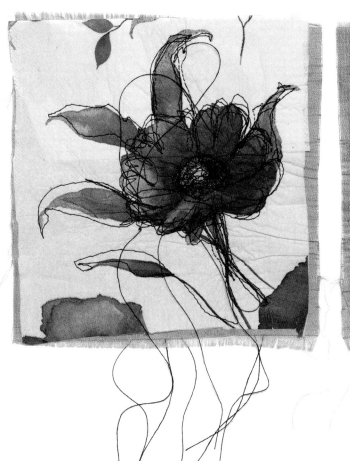

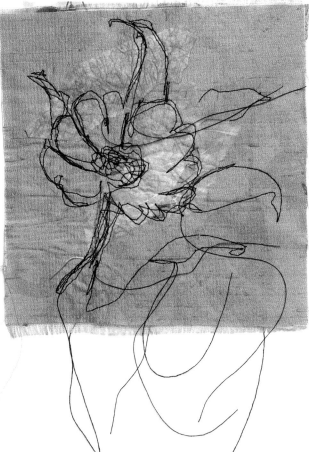

Some 'loosening up' exercises

If you are not used to drawing with your machine, you could try some of these exercises:

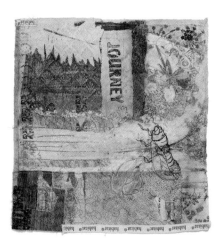

- Make a scribble drawing on lightweight paper or cloth and pin it to your fabric. Machine freely, using the embroidery or darning foot.
- Find a picture you like; look at it upside down, and then try to machine it directly on the fabric without drawing it first.
- Using a lightweight paper or fabric, make a line drawing of a group of objects or plants, without taking your pen off the paper. Attach this drawing to the back of your work and machine it. This is a good exercise for controlled single-line drawing with machine stitch.
- Explore moving the stitch width and length on zigzag to give a variegated line.

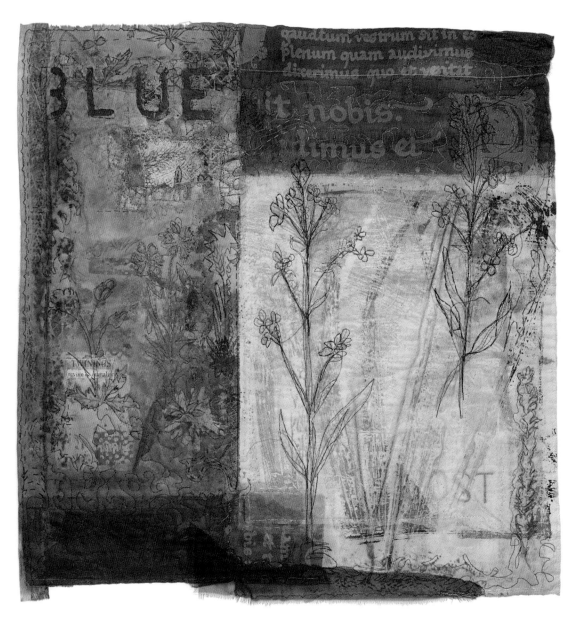

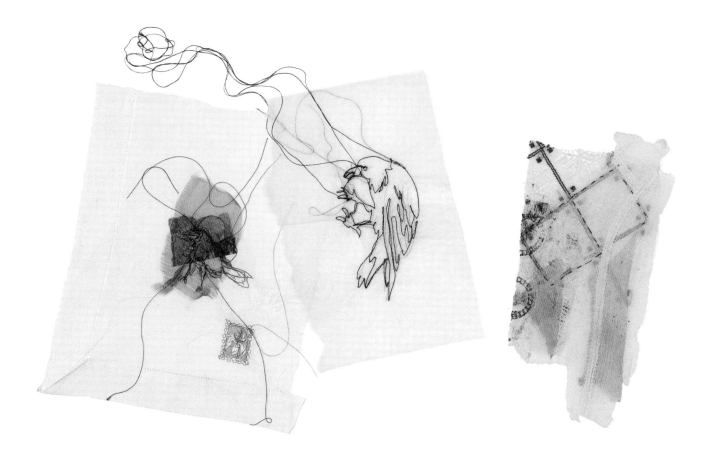

Free-motion stitch

Many of the techniques use free-motion stitch or embroidery, in which the feed dog is lowered on the sewing machine (some machines may have a cover plate for the feed dog) and the presser foot is removed from the machine. You are then free to control the fabric as you like, pulling and pushing it carefully under the needle. Usually, the fabric is held taut in an embroidery hoop, as the machine has difficulty in creating stitches in loose fabric. Instead of the presser foot, a darning foot or free-motion embroidery foot can be used, which holds the fabric close to the bed of the machine. This can be quite useful if your fabric is layered or stiff enough to permit this method of stitching. The presser foot lever must be lowered, even if there is no foot, as this engages the top tension. If this is not done, there will be a 'bird's nest' on the underside of the stitch.

It is important to get to know your machine and you should experiment with stitching on different surfaces for best results. Modern machines offer the possibility of creating a large number of stitch patterns and many come with computer-aided design, so a drawing can be scanned and stitched. You do not need the most expensive machines to get great results: I found my old Bernina 730 in a skip. A truly great found object! I would recommend that you look for a machine that can take a darning foot, and preferably has a feed dog you can lower, rather than a cover plate. A machine with a simple selection of stitches, including zigzag, and variable top and bottom tension, is preferable to something over-complicated (unless, of course, you really intend to use a great range of embroidery stitches). Some older machines are more solidly built than many modern ones and can take a lot of knocking about. Just ensure you buy from a reputable dealer, unless you know your stuff and cannot resist that flea-market find!

Above: Stitched samples. Bird and postage stamp; crow; stitched fragment of Romanian shirt.
Opposite, top: *Habitat.* Layered and printed fabrics and papers, overlaid with stitch.
Opposite, bottom: *Blue Flora.* Inspired by the useful plants in our lives, this collaged and quilted textile piece combines printed images of plants with stitch.

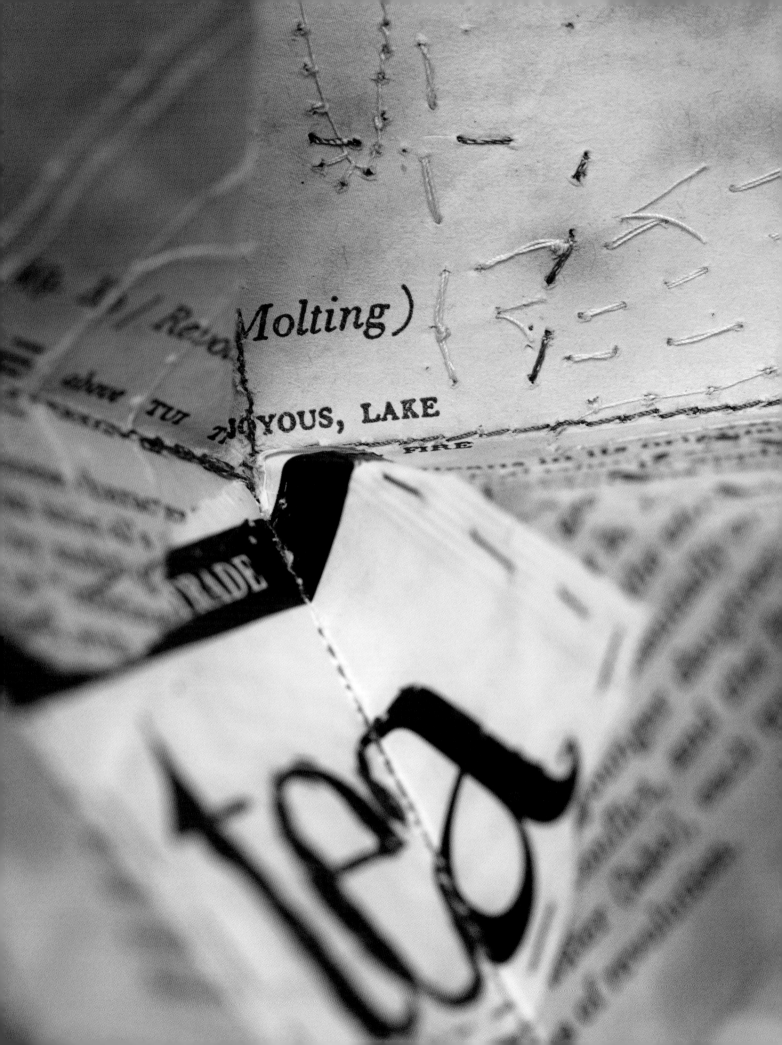

2 Use of the found

There exists a human compulsion to collect specimens, relics of the past. Through labelling, classifying and categorizing these 'findings', we try to make sense of our chaotic world. Museums, where finds are displayed and further contextualized and validated by diagrams and the written word, are evidence of our need to find meaning in these objects of the past. But note that more items are conserved and stored away, half-forgotten, in the basement of our museums than are on show.

In Western society, we are accustomed to adopting exotic objects from different cultures and countries. We visit our museums and galleries for inspiration and think nothing of adapting paper, threads and fabric from Japan or China in multi-layered textile works, or using beads and sequins from India to add interest to the surfaces of our textile creations. But what we consider as mundane objects or the discards of our everyday life are often seen as equally exotic to those who make textile-related work in other cultures. Bottle caps can be seen in Zambian skirts or are used to make painted brooches in Mexico, indicating how objects move across cultures, their transformation providing new meanings and contexts for the users.

Opposite: *Book of Changes: Book of Tea.* Pages from an old book used to create an origami folded-book form.
Below: A collection of brooches made from found materials. Clockwise from top: rose brooch made from a bottle top from Texas (Cas Holmes); wrapped slide mount (Judith Railton); *Microids* brooch made from electrical waste (Peter Weijers); pleated paper and cap-badge (Cas Holmes).

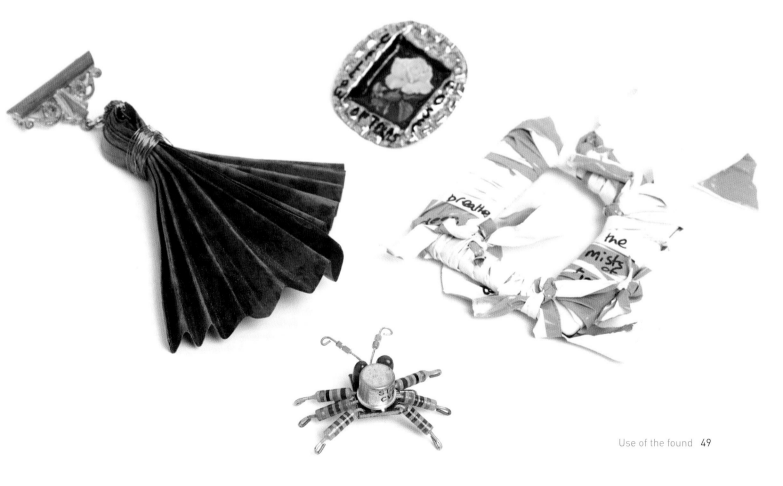

Found objects have their own individual life histories. Smaller manufactured items speak of their purpose, the consumer's need and the context of their use, but the personal biography of the found material can be used in new and original ways and their previous lives transformed to fit new purposes. An item to fasten paper – the staple or paper clip – can give added textural interest to the surface of a textile. Electrical wire can be used for stitching, adding weight and dimension to the cloth.

It is no surprise that today's textile recyclers are considering small discarded items as worthy of attention and, in addition to the usual textile and haberdashery supplies, are looking for new sources of small items for stitch- and textile-related work.

Below and right: *Little Birdies.* Bird brooch made from an Ordnance Survey book, on canvas (left) and hessian (right).

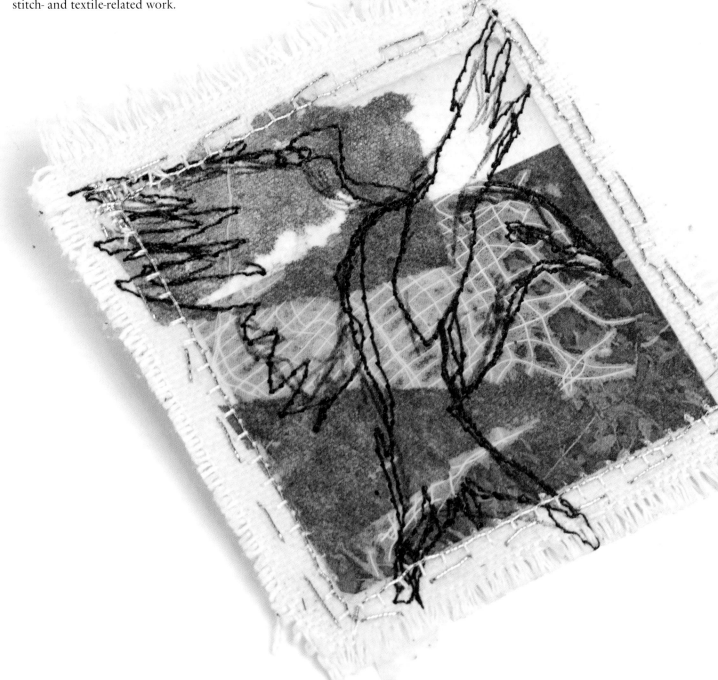

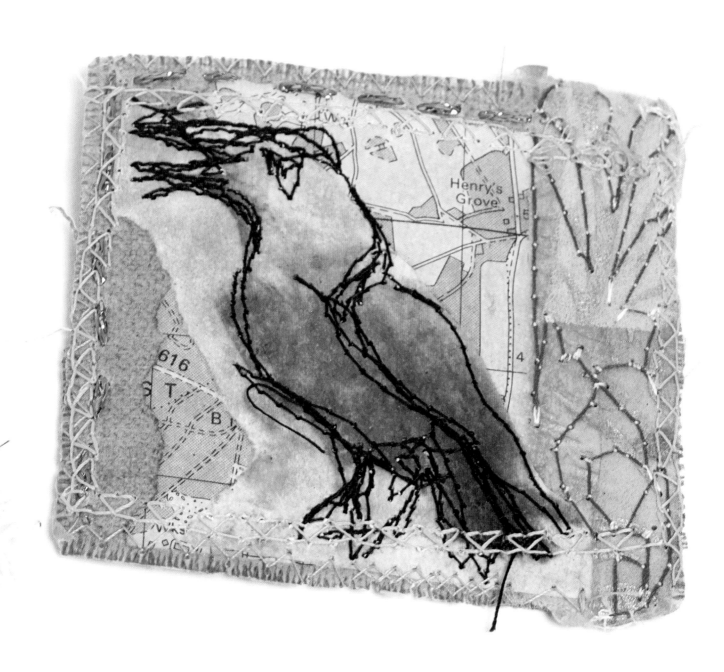

Look to the ground

I spend a lot my time walking. I don't own a car, and I never cease to be surprised at what I can find to use as part of the unnecessary discards of our not only wasteful, but often very messy consumerist lives. To quote a friend's expression, 'Our streets can often be enough to make a rat weep.' Most of my small finds occur on my regular journeys and the context of the find often helps to inform the work. My most recent research project in India inspired several pieces made entirely from street collections. These were wrapped up in fabric bundles, which I called my 'Cloth Babies', and were stashed in my suitcase to bring home for later use.

'Ground finds' largely fall into two main groups: organic and man-made. It doesn't matter if your reason for walking is recreational or purposeful, such as making your way to work or shopping, you can always look out for useful finds. You are, of course, more likely to find interesting natural materials when out walking in the woods or beachcombing, but unfortunately you are just as likely to find discarded plastic items and drink cans as you are to find driftwood and shells, small branches and stones.

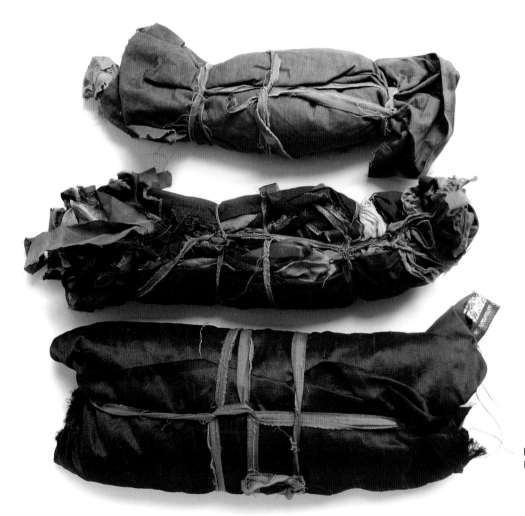

Left: *Cloth Babies.* Wrapped-fabric bundles from Indian streets.

Left: *Book Leaves.* Small book with twig detail stitched on the spine.
Below: *Small Bundles.* Marbles bound and wrapped in raffia and dyed cotton string.

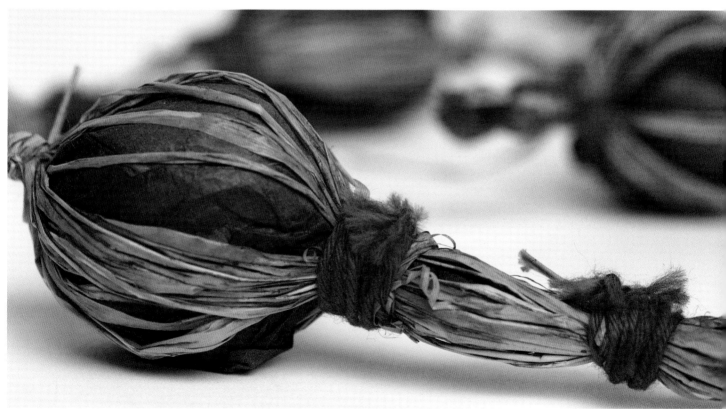

Suitable ground finds might include any of the following:

- Stones, shells and rounded bits of glass, washed smooth, can be used as beads, wrapped or sewn on in the same fashion as in Indian mirror work. If the items have holes in them, they can be suspended or attached more easily. Such finds can also be used for tie dyeing.

- Plastic waste, bottle tops, metal cans and rope are likely beach finds; however, when worn and weathered, they can be equally as interesting as seaweed or driftwood. Drill bottle tops to make beads, and stitch them in place with unravelled rope or twisted plastic. Good-quality sewing machines will be able to drill though flattened drink cans. These can then be cut up and machined onto a firm surface.

- Driftwood and small branches can be used to make interesting hanging devices or attached to the surface of the work, either using couching and wrapping or by drilling small holes and then threading and stitching.

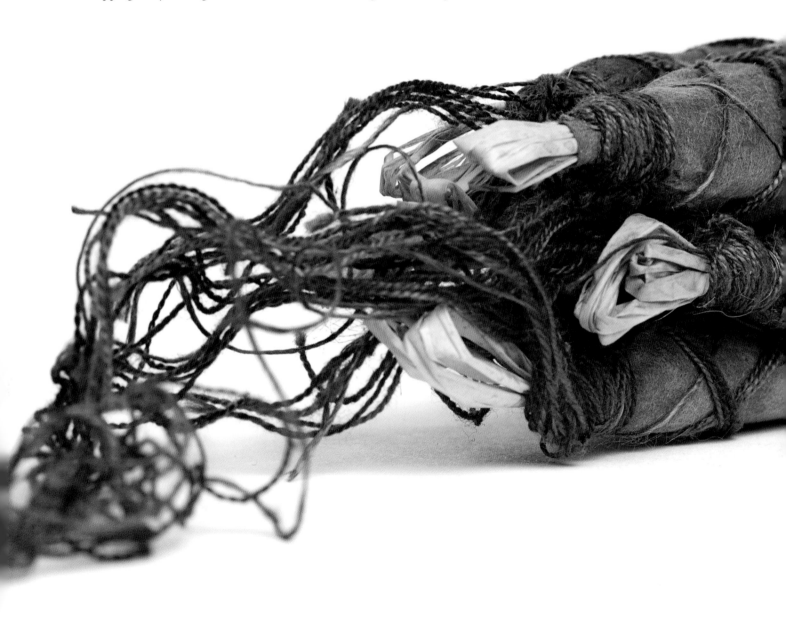

- Even the smallest find can be used. Wrappings from sweets and drink-can pulls can add bright touches of detail, appliquéd or stitched.

Sometimes, the items you find will lead to the development of an idea. During my studies in Japan, I collected small objects on my travels and, inspired by the packaging found to wrap all kinds of objects, from food to cloth and paper, I looked at new ways of wrapping, stitching and binding these little treasures. These were grouped together for exhibition and display, serving as a reminder of the intimacy of small packages and gift-giving in Japan.

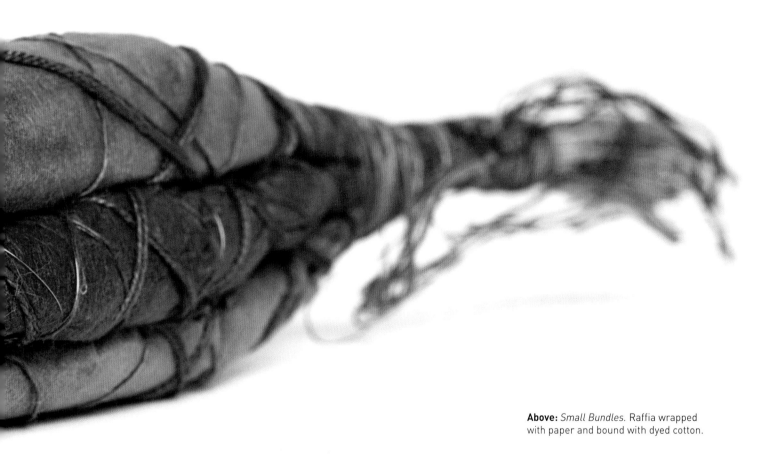

Above: *Small Bundles.* Raffia wrapped with paper and bound with dyed cotton.

Around the house

Increasingly, our food, kitchen products and almost every item we use in the house is packaged prior to use or is accompanied by disposables. Sue Pritchard describes her relationship with disposable medicine items:

'Once upon a time, a long, long time ago, we lived in a world where medicine was taken from a teaspoon. We already had the teaspoon and we used the same one over and over again (being sure to wash it in between). The medicine was dispensed in easily reused glass bottles, which we returned to the chemist when the medicine was finished.

Fragile Collar was made from the plastic measuring cups that were delivered with every prescription to a friend who was very ill and would need the medicine for the rest of his life. A measuring cup was duly delivered every fortnight. He saved them for me and asked me to make something from them. He wore a neck brace, so the idea of the collar came to me. I threaded the cups like beads and then used the plastic bags (part of the packaging that his paraphernalia was delivered in) to crochet a foundation and create a fringe.'

There are always plenty of items to use in the kitchen. Foil lids from cat-food trays and yoghurt pots can be rolled, wrapped and stitched. Matchsticks can be bound and wrapped. Plastic bottle tops and can pulls may be attached and laced.

Old 'findings', such as bits of old jewellery, beads and buttons, can give added interest to a surface. Look in the tool box for metal objects, such as washers, screws and lengths of electrical wire, as alternative 'little jewels'. The home office can be a useful source of paper clips, staples, paper fasteners, pen lids and so on. Finally, don't forget the garden. Garden mesh, plastic ties, old labels, garden cane and wire – all these can be used for stitching and attaching.

Right: Paper panel sample with electrical waste and safety pins.

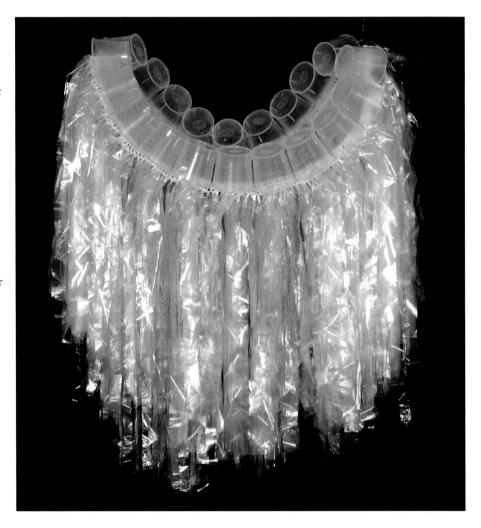

Right: *Fragile Collar* (Sue Pritchard). Plastic measuring cups and bags.

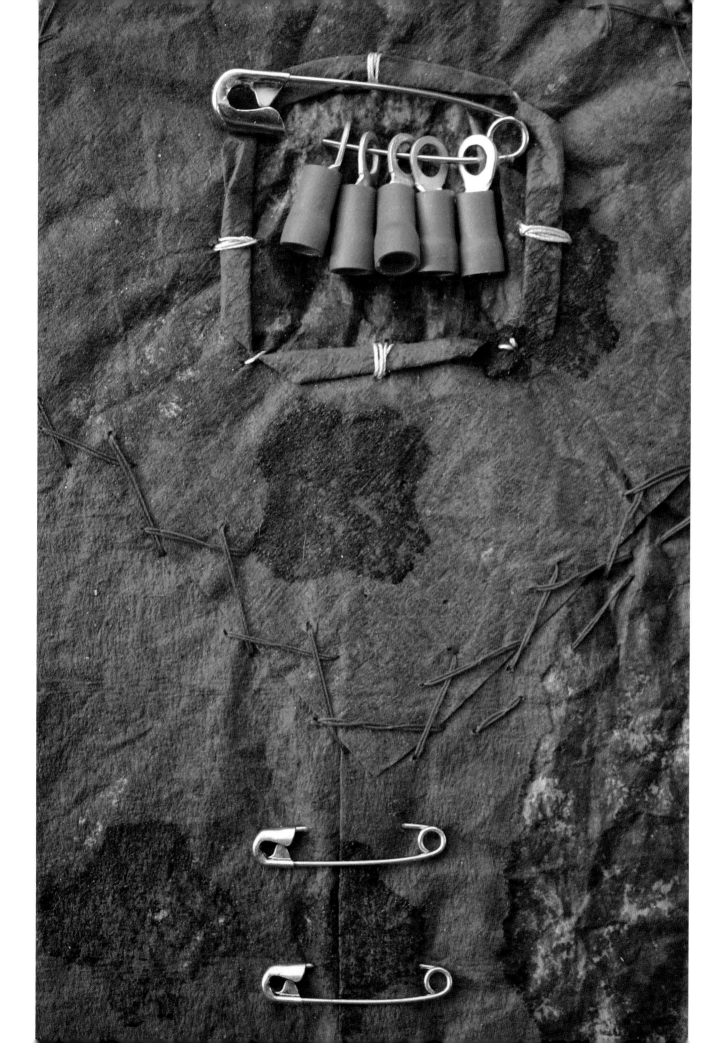

Alternative shopping and useful tools for little finds

Finally, just in case you cannot find enough small items, you can always use alternative stores to art suppliers as a source for useful additions to your collections of small objects. Often, you can find bargains if items have been opened or have some damage. DIY stores or building suppliers, garden centres and stationers are really useful places to find a multitude of small treasures, from nuts and bolts to string. In addition, these are the places you need to visit to stock up on some of the useful tools you will now need. Unless, that is, you can borrow them from someone willing to lend them!

I would recommend the following useful tools to supplement your textile-work box:

- Pliers, wire cutters, a small hand drill, hammer, clamps.
- Sandpapers of various weights.
- Staplers, hole punchers.
- Selection of wires, for attachments.
- Heavy-duty carpet tape – really useful for making small print blocks and temporarily holding objects.

Cloth, paper, text and image

Reusing textile items found as part of your practice can be deeply satisfying from a creative and expressive point of view. Fabric and paper, in various states of preservation, or decay, carry their own references. These two materials are the most familiar to us as part of our everyday lives. Paper, in all forms, is so familiar that it passes through our hands almost unnoticed, whether it comes in the form of shopping lists, bus tickets, notes, kitchen paper or toilet rolls. We have such an intimate relationship with paper that it is taken for granted. In this age of the personal computer, paper still lays claim to countless ways in which we communicate. We still prefer the hard copy for many things, such as wedding invitations, personal letters or birthday greetings. For artists, paper remains the most immediate of materials for recording ideas. Printed or written matter, such as books, maps, old letters and postcards, can be used effectively as starting points for your work.

Vintage, old or discarded textiles have long been associated with reuse. Where money was scarce, or simply because the fabric was valued, necessity and inventiveness combined to extract full use from all textiles around the home. Expressions such as 'waste not, want not' and 'make do and mend' are a legacy of a practical philosophy in which waste, of materials or time, was seen as wrong. I remember wearing my sister's hand-me-downs in the early 1960s, when the legacy of frugality was still a very real memory for my parents and grandparents, who had not long been out of rationing from the war years.

Right: *Rouge.* Using red as a theme, this stitched drawing of red madder also uses pages from an old book, prints from custard-cream biscuits and rubbings from lace to reflect the domestic heritage of floral textiles.

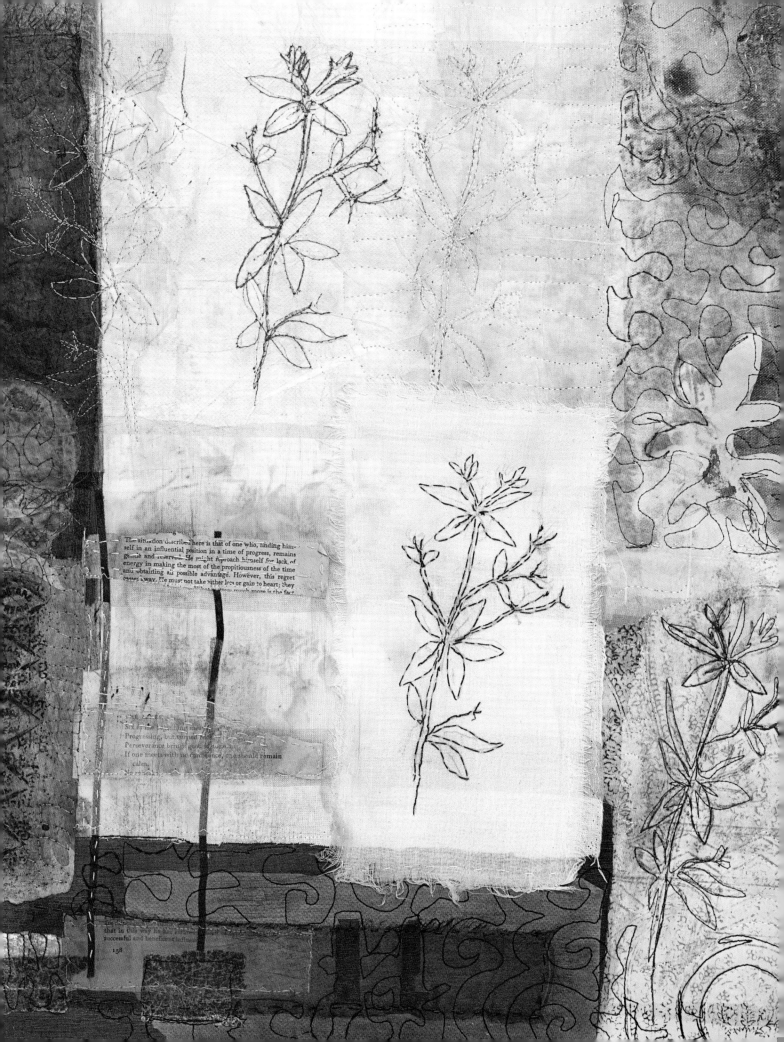

The situation described here is that of one who, finding himself in an influential position in a time of progress, remains gentle and reserved. He might reproach himself for lack of energy in making the most of the propitiousness of the time and obtaining all possible advantage. However, this regret passes away. He must not take either loss or gain to heart; they are of slight importance, much more is the fact

Six in the fourth place means:
Progressing, but turned back.
Perseverance brings good fortune.
If one meets with no confidence, one should remain calm.

that in this way he can further the general welfare, and a successful and beneficial influence.

158

Patchwork quilts are perhaps the most common expression of thrift. Made up of small pieces of fabric, quilts were a useful way of rescuing and reusing fabric, whether from old dresses, overcoats or blankets. The good parts were trimmed and reused to create a new layered fabric, which often combined warmth with really inventive design. My grandmother's 'red-cross' quilt, sent over from Canada after the bombing of Norwich, was a good example of thrift and necessity. I remember using it as a child when staying with her. When it passed to me, I spent time repairing the quilt with pieces of my old childhood dresses and used it on a guest bed for several more years. All that remains now is a small cushion for an old chair in our bedroom and small salvageable pieces I put in my cloth stash and which I have now used in textile pieces.

Most people will have in their homes examples of old fabrics, such as oddments of lace and handstitched samples, that could be referred to as 'vintage', and these serve as a connection to the past. The collection of the more intricate and historical types of these fabrics has long been desirable, but as more textiles become mass-produced, the value of any handmade work has increased. Old fabrics, handstitched textiles, books and papers are inspiring because of their tactile, atmospheric and versatile qualities, and bring with them their own histories.

Outside the home, second-hand shops, charity shops, markets and car-boot fairs can be good places for sourcing old fabrics and papers.

Below: Swallow print on the edge of an old cotton cuff (top); crow image transferred to cotton sheeting (bottom).

Vintage and second-hand textiles

The term 'vintage textiles' can be used to describe many kinds of old or worn fabric and textile products, many of which may contain beautiful handiwork. The everyday and historical importance of these old textiles cannot be overstated.

Old lace, handstitched back rests, embroidered clothing and quilted bedcovers represent many generations of handwork by makers, mainly women, who embellished the textiles found in their immediate surroundings and environment. To reuse these creatively celebrates and pays tribute to women's domestic arts. The imagery used in these textiles can be rich and detailed or naive and simplified, and can lend interest or act as a starting point for your own work. The texture of older found textiles is often more worn and soft than that of new fabrics, making them easier to handle and more receptive to being dyed and printed, and thus altered, before they are worked with stitch.

Below: Handmade lace from China, and a vintage lace doily.

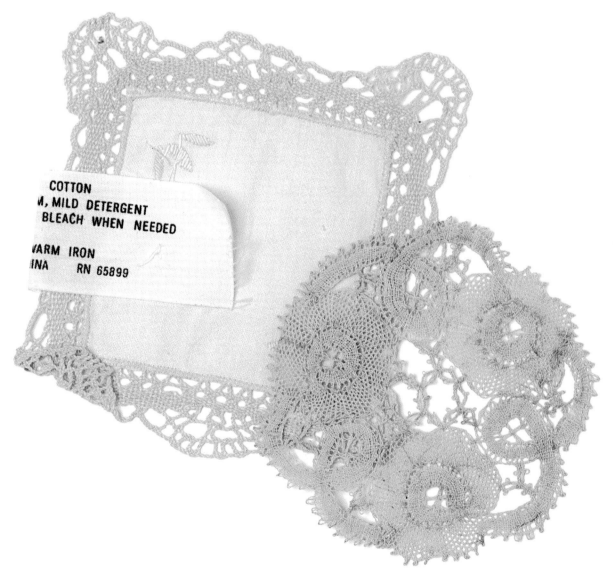

Sorting the textiles and papers

It is useful to sort collected textiles and papers in much the same way as you would organize threads prior to selection for sewing. This enables the textile artist to visualize the possible combinations of colour and texture before beginning a piece. I use two main systems for sorting: any collected vintage or found material is initially sorted into two broad areas, paper and textile, and these are then subdivided into categories:

Paper

Domestic: coffee filters, teabags, doilies, serviettes.
Text: old books, photocopies, magazines, old letters, stamps.
Specials: Indian, Japanese, handmade.
Printed: wrapping paper, paper bags, flower wrappers.
Collections: from walks, journeys and so on.

Right: Vintage kimono fabrics.

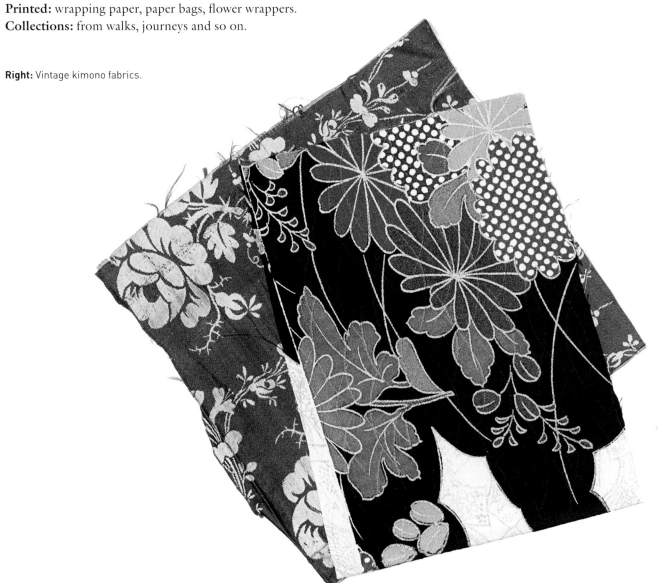

Textiles

Ethnic groupings: Indian embroidered muslin, Japanese silks, old clothing.
Vintage neutrals: lace, linen, handstitched samples.
Vintage coloured: old clothing, patchwork, cushion covers.
Coloured: dyed, printed and hand-stained cottons, silks and other natural fibres.
Small: threads, string, ribbon, buttons, lace scraps.

When I start working, I draw out pieces from my collections and lay them on a clean surface before making a selection of those that may suit the project in mind. These are then placed into open boxes and baskets to be drawn upon as I work. As I develop my ideas with dye, paint or stitch, I constantly move between my collections, pinning and displaying the materials against a white background, which enables me to isolate and amend areas that may be of interest or show potential. Sections that have been worked and stitched and then rejected find their way back into my collection boxes and can then be used again, either in my own work or in community projects.

Below: Fragments from an Indian cushion cover, French brocades and organza.

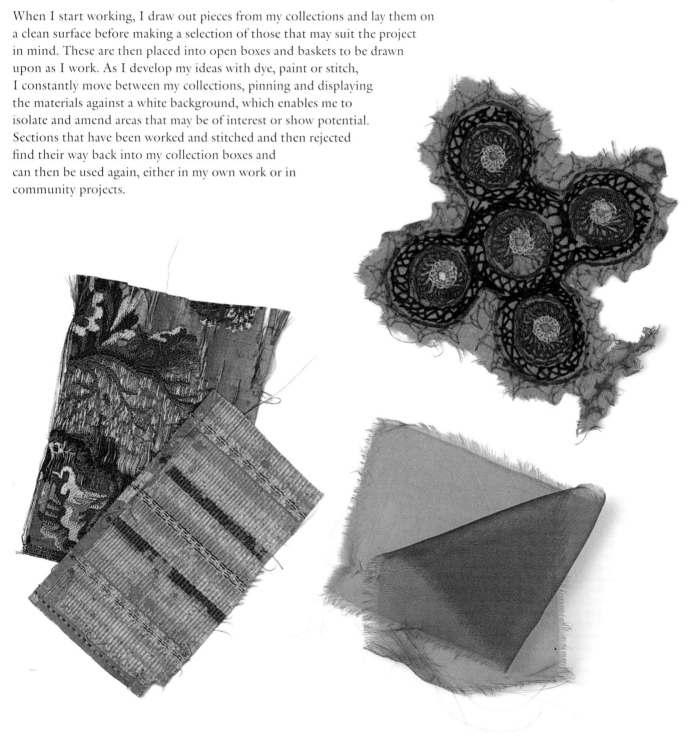

Changing the 'textile'

The fabrics and papers you use may have been collected on a special journey, or have some other personal reference. Materials could be of interest because of socio-political or historical links, such as old jeans, lace handkerchiefs or old letters. Perhaps the materials are right, but they need to be further homogenized to bring them together, or they may need to be in a different colour range. There are several ways you could effectively change your found textiles and paper to bring more cohesion to a piece of work.

Colour
Printing and mark-making methods have been covered in Chapter 1, but it is worth taking a look here at additional dyeing and painting approaches as ways to change your found or vintage fabrics.

Dyeing
Check your fabric first to see if it is suitable for hand dyeing and will be receptive to the dye process. Most cottons, linens and fabrics made from plant fibres will work well with cold-water dyeing processes.

- You can use fabrics that have a similar texture or type in a limited colour range. You could hand paint the fabrics or dye them in a dye bath to bring more harmony to the pieces, despite their pattern or intrinsic colour. Alternatively, you could place the fabrics in a washing machine and use machine dyes.
- Try tie dyeing, fold dying or 'low water' immersion-dye methods, using small containers to hold the fabric so that not all the surface of the fabric is in contact with the dye, giving interesting shifts of colour.
- Simple bleaching removes colour and makes fabric more neutral, which can help to bring different elements together. This works well on cotton and linen, but can cause silk or wool to disintegrate.

Below: Chain-stitched fabric waste used for printing.

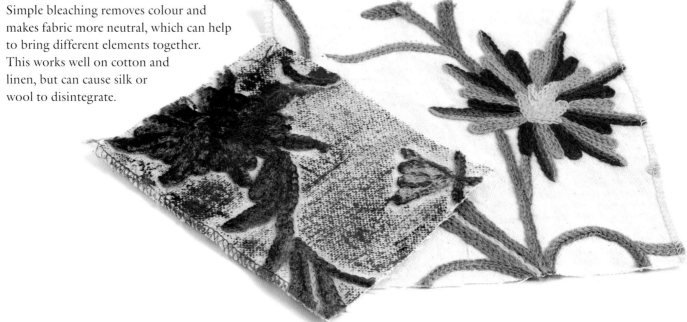

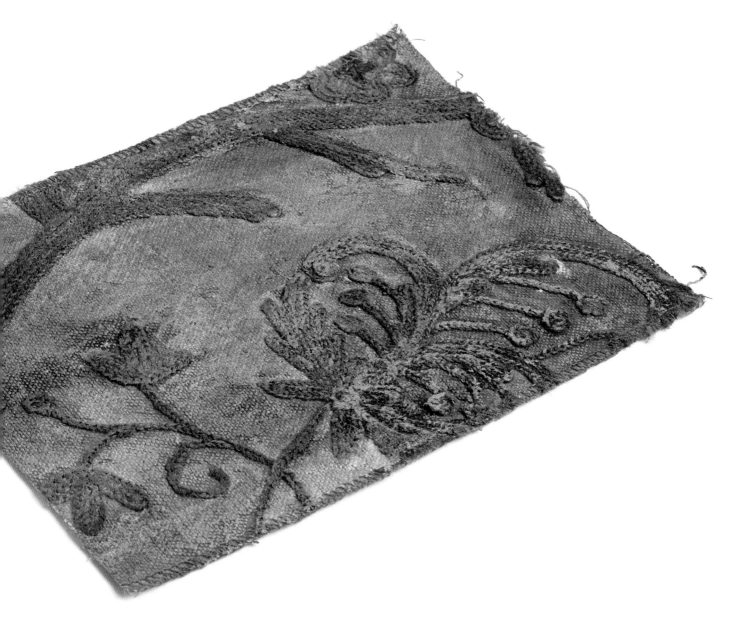

Painting

Consider staining and marking the surface of fabrics. Surface painting could be applied to small sections or act as a way of changing large surface areas, bringing disparate elements together.

Above: Floral relief fabric painted with acrylic and rubbed with gold powder.

- Crinkle the surface and rub with fabric crayons or pastels.
- Rub fabric crayons or pastels onto textured or quilted fabrics and papers. The crayon marks will be more dominant in the raised areas, such as areas of heavy stitching or lace, leaving less colour in recessed areas, such as the quilted stitch lines.
- Create interesting effects by brushing or rolling fabric paint, acrylic or even emulsion paint across stitched fabric. Change the texture of the surface by mixing in a little textured paint, plaster or other thickening or textured media. I have even used clay with Marvin medium.
- Mix bronzing powders and gold and silver acrylic paints for a more lustrous surface.

Size, shape, pattern and images

Select fabrics and papers that have similar qualities, such as texture, colour or pattern, to create new surfaces. Consider the inherent qualities of the pieces. Often, colours and patterns within a piece can evoke a unique time and place or evoke nostalgia in the maker and the viewer. Some imagery can reflect and reinforce meaning: vintage buttons or the cards that they were mounted on, for example, could be used to add an area of interest – almost as punctuation. Ribbons, lace, string and cord can create boundaries or unite disparate elements. Papers and fabrics that relate to the home or garden may comment on a personal history or the social and community aspects of a given locality. Handstitched text, lace or crochet work could be used to suggest aspects of the domestic history of textiles, such as the creation of samplers. Seed packets, potato sacks or garden netting could be incorporated into a series of works looking at local allotments and gardens or be used to make a comment on organic gardening.

Below: *Iris and Birds.* Layered paper, vintage fabric and seed packets.

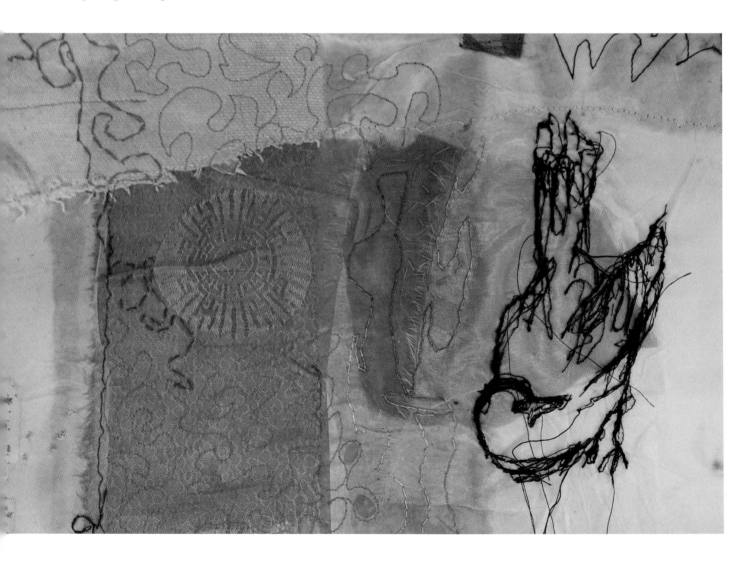

Paper and text

We take pleasure in our ownership of books as objects, not just because of their contents, and the same applies to other materials containing text, such as packaging, letters and parcel wrappers. The appropriation of found images and text has long been used in collage work by artists. Fragments of everyday lives – travel tickets, receipts, scraps from torn pages, paper wrappers and old posters – intrigued artists such as Pablo Picasso and Georges Braque and were used by them as a primary medium in their constructions. These same fragments have equal value for the textile artist today.

The material nature of paper can be explored and changed. Softer oriental papers work well with fabrics; harder, more resistant papers can be used as a contrast or softened with crumpling and manipulation. However, by far the most important aspect of paper is its use as a carrier of images and text. The physical and aesthetic qualities of text and related narrative imagery can be altered and incorporated as 'found elements', adding to the complexity and meaning of work. Old papers, manuscripts and music sheets are especially intriguing. Made of handmade paper, papyrus or other precious materials, they were often scraped and reused. Even in recent history, during the Second World War and shortly after, paper was a valuable resource. My father, then at Norwich art school, had to use both sides of his drawing paper. His later air-mail 'blues', sent to my mother from the Korean front, were crammed with tiny writing, which covered the front, back and edges. Text, old letters or photocopies can sometimes appear as palimpsests, ghostly echoes of the old mixing with the new, creating layers of surprising juxtaposition in textiles.

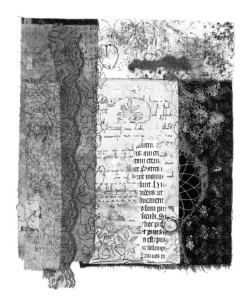

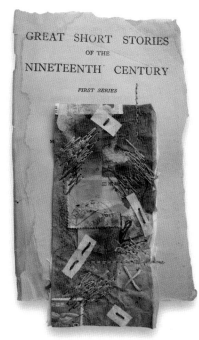

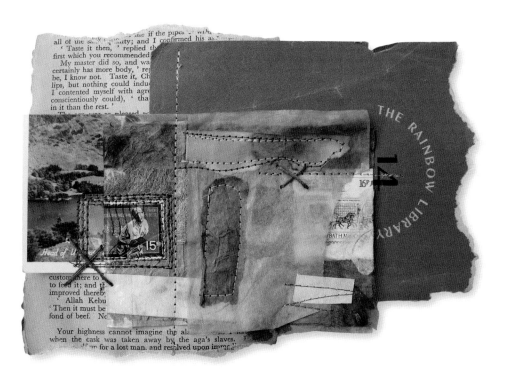

Left and above: Working samples (Carol Tulloch) using book pages and various collected papers.
Top: *Journal*. Mixed fabrics and text including fragments from my father's letters.

Using clothing

Cutting up an existing garment, undoing seams or making prints from parts of a garment can also be a useful departure for an artist. You can create focal points by incorporating parts of clothing into your work, using features such as buttonholes or collar edges. Pieces of clothing can dictate and alter the mood or feel of a piece, according to their placement and use. Equally, their manipulation can add a huge amount to the depth and complexity of any size of work.

Printing from a whole piece of clothing, using both the print and the clothing to develop new pieces, can be very evocative. The idea of adding paper patterns, pages from old textile-technique books and other items related to garment-making is an interesting addition to the notion of evoking narratives with forgotten textiles. Equally, old clothing can have cultural and historic resonances relating to specific times and people. Whole pieces of clothing can be stitched into a work and found objects added to the surfaces.

Below: *Spick and Span.* Traditional waitress's uniform from Germany and tea towels reflect domestic 'female' heritage.

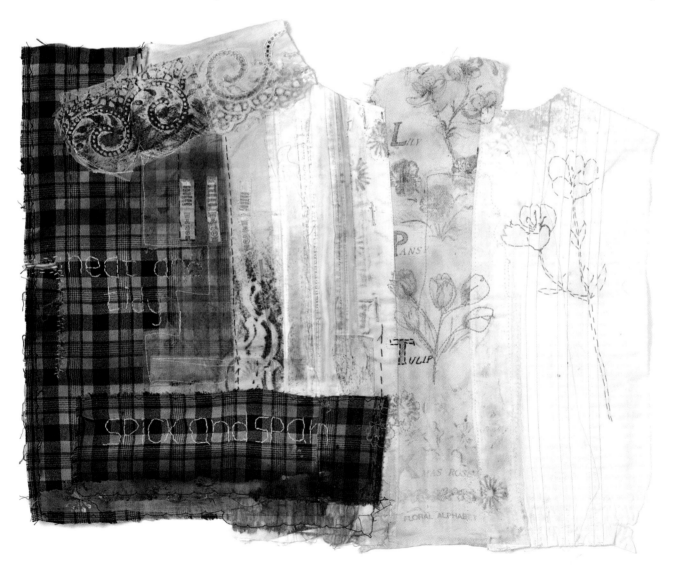

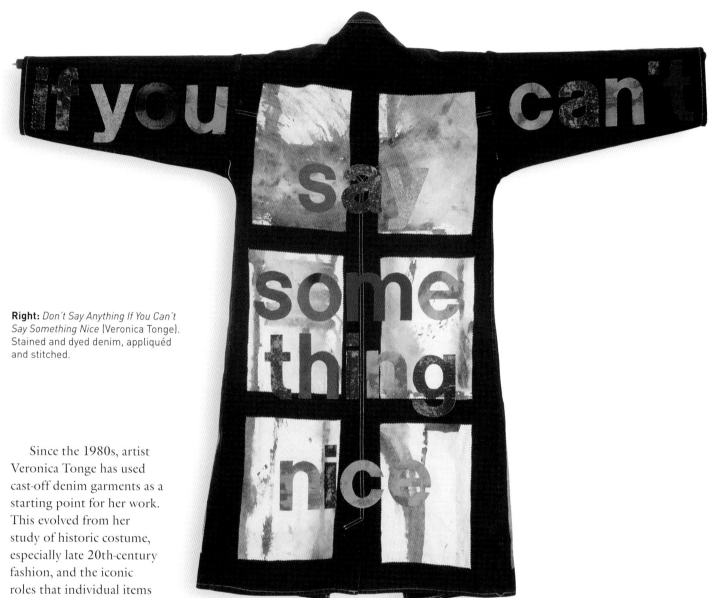

Right: *Don't Say Anything If You Can't Say Something Nice* (Veronica Tonge). Stained and dyed denim, appliquéd and stitched.

Since the 1980s, artist Veronica Tonge has used cast-off denim garments as a starting point for her work. This evolved from her study of historic costume, especially late 20th-century fashion, and the iconic roles that individual items of clothing (such as the coat) played in the development of both fashion and culture.

Recycling 'unwanted' clothing is, for Veronica, a statement about turning low-value, ordinary people's fashion into meaningful art. As a medium, denim's strong twill weave is very like the traditional artist's canvas in feel, offering a versatile ground. This she dissects, turning the garments into large wall hangings. Sometimes she works directly onto them, using a combination of bleaching, dyeing and washing, allowing denim's characteristic fraying process to develop. The construction methods often incorporate additional 'found objects' as a means to engage the viewer and provoke thought. Text is often applied to add clichés and metaphors, mostly reflecting personal or universal human emotional experiences. The title of each of her works is carefully considered, often offering an ironic clue to the meaning.

Stitch, culture and memory

Some fabrics have more meaning for the maker than for others. Memorabilia collected on your travels or referencing a visit to a museum or gallery could be used to comment on your experience and your exchange with other makers from a different culture or time. Any materials collected from other cultural or historical sources should be used and treated with respect and care taken in their application and suitability of use. In more recent work, scraps of Indian printed fabrics and embroideries from Rajasthan and northwest India served as a means to explore the cultural links between North Indian art and decoration and those of my own Romany heritage, within a broader cultural context. Specifically, I remember similar colours in the surroundings and objects decorating the shelves and cabinets of my Romany grandmother's home.

Metallic, beaded or sequined fabrics can be layered into work to create shine and a glinting sense of surprise in the piece. Even though they may have been inexpensive, the jewel-like quality of these fabrics makes them ideal for further manipulation. Small scraps are sold as remnants and 'ends' in sari shops in India and closer to home. Layering these fabrics with machine and handstitching helps to expose these exciting qualities. The quality of stitch you use should reflect and enhance the existing embellishment.

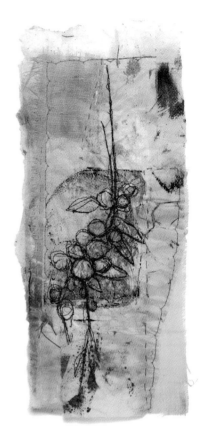

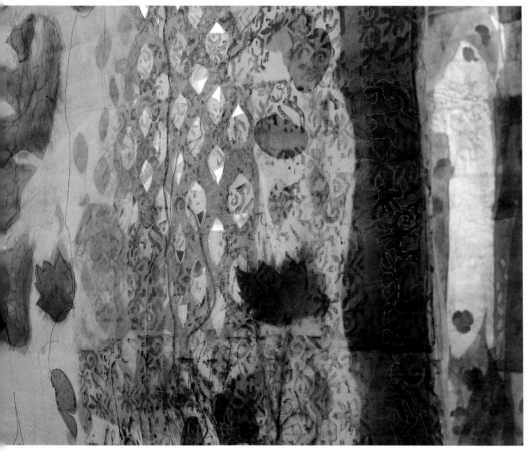

Above: Berry motif machine-stitched onto layered fabric and paper.
Left: *Traces*. Installation in Rochester Cathedral using vintage Indian fabrics and cut papers to create a light, 'openwork' feel.

- Look at the patterns in your fabric or papers and hand or machine stitch the lines. Consider using textural stitches, as well as decorative ones, to enhance the underlying patterns and shapes.
- Consider how different layers may be combined. Could they be stitched into a three-dimensional form or be made wearable, using an old dress pattern?
- Incorporate fabric pieces, text, threads and cut-up embroideries and paper waste into your stitched layers.
- Crease and fold surfaces before stitching them down.

Adding new imagery and motifs sourced from found textiles and paper creates an exciting and original juxtaposition to stitched work, adding texture as well as colour.

Textile artist Anne Kelly mixes vintage textiles into her stitched and multi-layered pieces. She started scouring jumble sales and charity shops for fabric and vintage labels to incorporate into her patchwork textiles while still at school. She now uses them as an integral part of her 'layered embroideries'. These reused textiles give an immediate patina and authority to her narrative-driven work. The textile fragments inform her pieces, their visual content often deciding the subject and title of her work.

Anne is particularly interested in the commonplace and everyday aspect of these textiles and uses them with originality to create a seamless, but completely changed, new fabric. She chooses old tablecloths, samplers, printed and stitched canvas and any fragment of embroidery that may fit in. She has also dolls' clothing, second-hand garments and headwear as backgrounds or focal points in her work. These seemingly incongruous and random items are absorbed into the final piece with heavy stitching. They are then overstitched with hand and machine embroidery. The action of sewing combines the layers into a uniquely sculptural textile surface.

Whether discarded, found, bought or haggled, the use of any old textile and paper materials can enrich and enhance your practice.

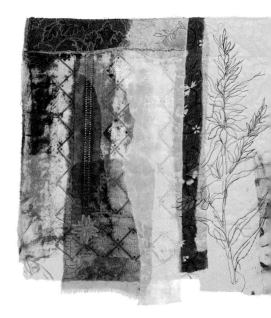

Above: *Purple Loosestrife.* Vintage Romanian blouse, waste fabrics and machine-stitched drawing link culture with memory.

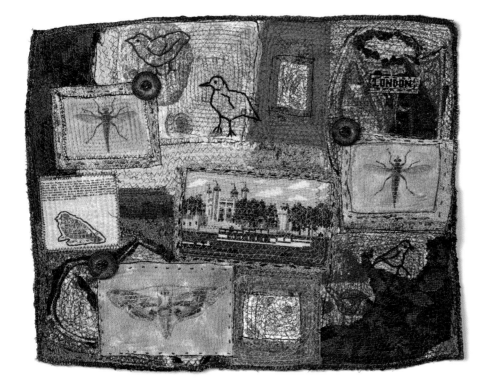

Left: *London Town* (Anne Kelly). Drawings stitched onto heavily layered fabric combine a vintage 'feel' with a very modern outlook.

Transforming objects

The term 'found art' – or, more commonly, 'found object' (French: *objet trouvé*) or 'ready-made' – describes art created from the undisguised, but often modified, use of objects with a mundane, utilitarian function. It was the avant-garde movements of Dada and Surrealism, particularly the works of Marcel Duchamp and Kurt Schwitters and the writings of André Breton, in the early twentieth century, that had an important bearing on the artists' use of mass-produced objects, photographs and the printed image to form assemblages.

The found object usually has some significance or meaning placed upon it by the artist. Indeed, for the textile artist, the use of the object has to go beyond an interest in investigating new surfaces and textures for his or her work. The idea of dignifying commonplace objects in this way was originally a shocking challenge to the accepted distinction between what was considered art as opposed to not art. Although the use of found materials in art is now widely accepted in the art world as a viable practice, it continues to arouse media and public attention. Such was the case with the Tate Gallery's Turner Prize exhibition of Tracey Emin's *My Bed*, which consisted literally of her unmade and dishevelled bed.

The use of the found, however, has to have the artist's input, or at the very least an idea about how it could be reinterpreted. There is also a degree of modification of the object, although not usually to such an extent that it cannot be recognized. This use of the found object in textiles provides exciting avenues to the artist, offering a means to explore new interpretations or adaptations for their work.

Below: *Sweeties ¼lb.* My father had a sweet tooth, as do I. These are some of his favourites, made from recycled handmade paper.

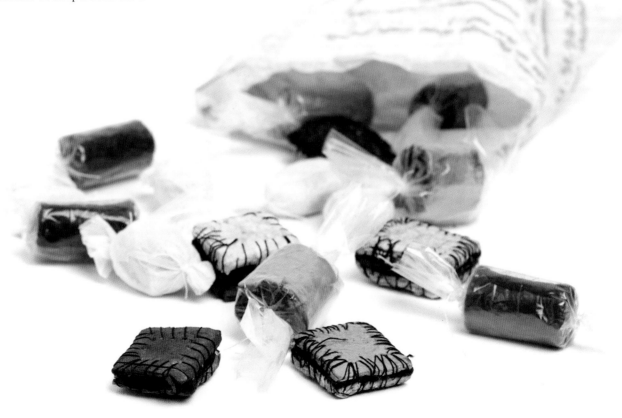

Found containers and boxes

The definition of the box is simple enough: a case or receptacle for containing something. It is the simplicity of the box's form that makes it so accessible and versatile, attracting artists to appropriate it, transform it or make assemblages. A box is the single object that appears most regularly in our daily lives, from packaging for food or cosmetics, to cupboards to house our belongings or even the cars we travel in.

A box is mysterious; we all mentally shake the wrapped packages under the Christmas tree, eagerly opening a box of perfume or chocolate treats. Pandora could not resist opening a box and, as a consequence, unleashing sins and suffering on the world. The myth points out that the behaviour of Pandora is archetypal – she was unable to resist the mystery of the closed container.

A special function of the box is that it often acts as a receptacle for memories. I have boxes everywhere in the house, many of them containing my collections for reuse, such as buttons, beads and small objects. Others contain more personal memorabilia: letters from my father, a converted gun case to house numerous old brooches, boxes of family photographs, and all manner of things which are too precious to dispose of.

Beach Finds contains special memorabilia from a day at Sheerness in Kent many years ago. While looking for fossils, I found many other objects not usually associated with the beach and an old box that looked as if it may once have contained inks. Using a newspaper from the day, layers were built up with paste over the cardboard frame of the box, finishing with a final layer of handmade paper. While it was still wet, I made impressions into the paper by pressing shells against the surface before the box was allowed to dry slowly in the sun. I used Quink ink and dye to stain the surface of the box. The found objects were similarly covered with thin paper and allowed to dry before stitches were added. The meaning of the work is simply to act as a reminder of a particular day and a comment on the unusual items it is possible to find on a beach.

Above and below: *Beach Finds.* Cardboard box covered with papier mâché and stitched found objects.

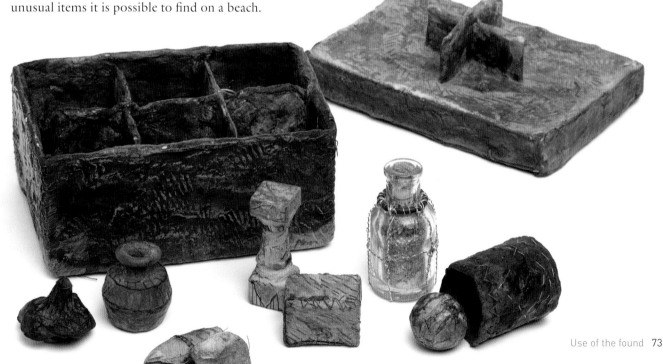

Fairy Tale Boxes, on the other hand, made using similar layers of paper and stitch, refers to the fairy tales in children's books and the moral themes within the stories. Sometimes the stories are quite savage, and the female role is often represented as demeaned or concealed in some way: the heroine of the tale is often disguised, maybe a princess in hiding, and at times imprisoned or controlled, as in the tale of Sleeping Beauty or the popular pantomime favourite, Cinderella.

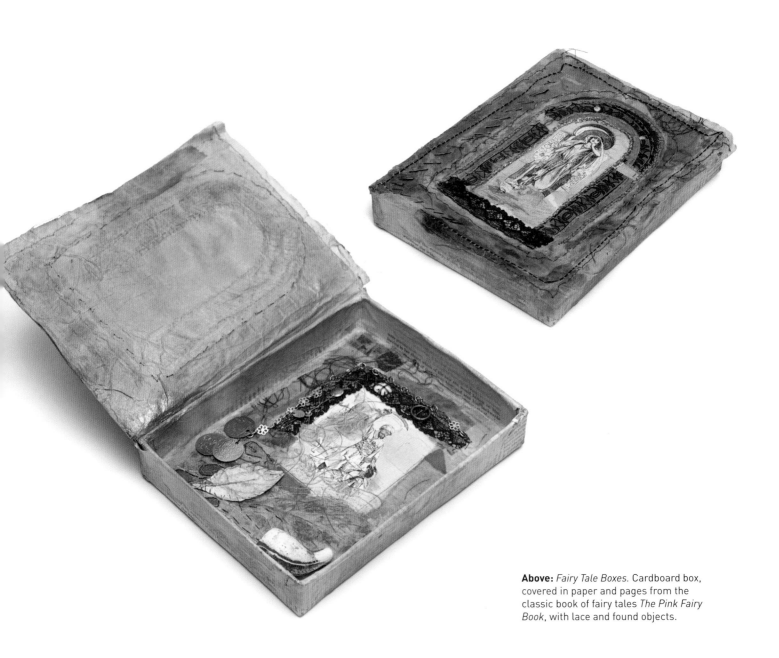

Above: *Fairy Tale Boxes.* Cardboard box, covered in paper and pages from the classic book of fairy tales *The Pink Fairy Book*, with lace and found objects.

In *Transmutation*, Penny Burnfield makes reference to the human compulsion to collect and categorize. Originally trained as a doctor, her medical experience has since evolved in her work. Like specimens, her pieces are carefully made, using materials such as yarn, felt, paper, wax, thread and wire. These are almost surgically mastered with a range of processes, from stitching, wrapping and binding to burning. Often forming collections, as seen in *Transmutation*, her work is modular, with organized sculptural pieces being presented like specimens on a shelf.

Burnfield says of her work, 'Labels are necessary, but these are often unintelligible to the casual observer, who does not understand the codes and reference numbers. My labels are also cryptic, and refer to the development of the work in my own codes.'

Drawing on artefacts of the past, and the history of science and alchemy, she continues, 'I am interested in the development of writing. I am always drawn to any artwork which consists of repeated units, grids, collections. My work is usually in the form of multiples and the relationship of the parts to each other, in space is central to any piece. Formal qualities – abstract composition, surface and colour – are important and the finished work must give me (and the viewer) some aesthetic pleasure, whatever its content.'

Below: *Transmutations* (Penny Burnfield). Cardboard boxes and wrapped and stitched 'specimens'.

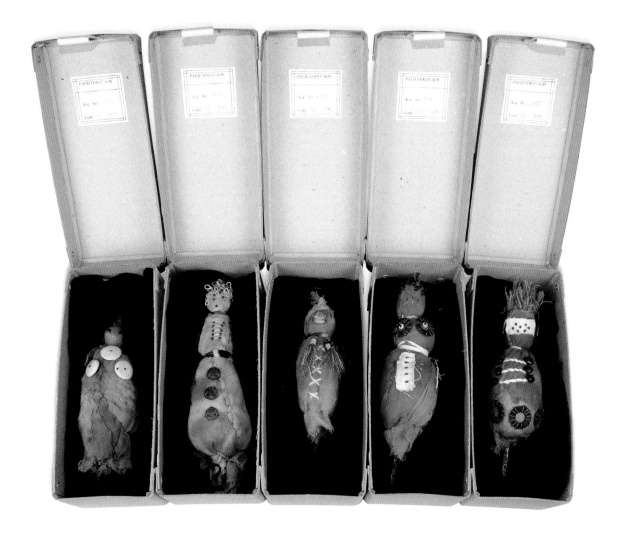

Book forms

A book is the simplest of portable forms in which to contain the written word, with its seductive ability to hint at meaning, create rhythms or hidden codes, and to hold images and designs in many forms. That artists use this form so frequently in their work is a testament to its familiarity and to its use in suggesting the unfolding of ideas and knowledge within its pages. Formal bookbinding is a craft older than printing. Beyond its functional purpose of preserving important information, the book has the capacity to contain creative images, beauty and ideas in the pages held within its covers.

Below: *Mehndi.* Concertina book made using a mehndi stencil.

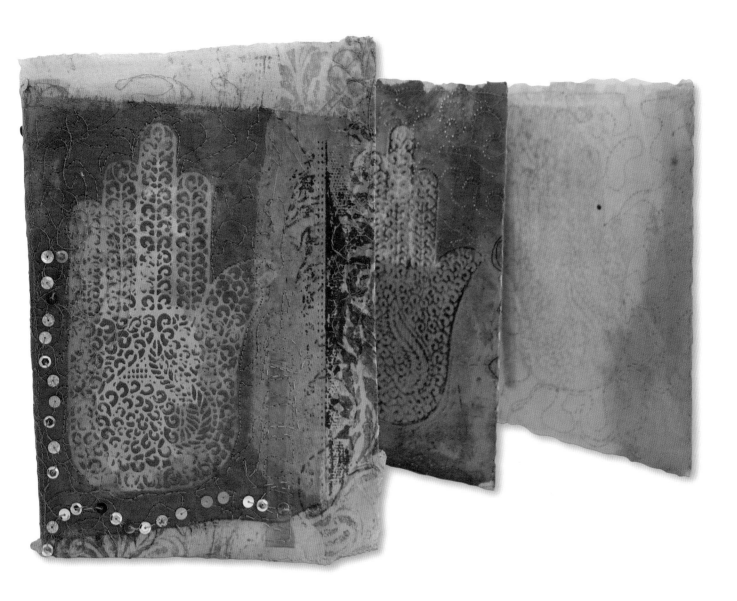

Simple journals from folded paper

A good introduction to making simple books is this one, which requires the minimum of sewing. A book can be traditional in format or you can use folding techniques. Folded books can be made from virtually any sheet of paper, torn or cut. You need very basic tools, but it is essential to have a good bone folder, to make creases sharp.

It is also useful to know where the grain of the paper lies. Folding along the paper grain will produce an easy, smooth-edged fold that functions well and looks and feels right. The grain direction (how the pulp fibres lie in the paper) also determines how the paper will tear and how it is glued. Paper tears more smoothly in the direction of the grain, rather than across it, and, if dampened with glue or water, paper is stronger in the direction of the grain. This is why stretched paper sometimes tears as it dries, because of the different pull on the fibres.

In order to determine the grain direction of paper, place it on a flat, clean surface and loosely roll over one half, taking care to avoid creasing. With the flat of your hand, as though about to roll the paper into a tube, bounce/press it lightly. Try to remember what it feels like in terms of pressure and resistance. Then turn the paper around 90 degrees and repeat the process. With one of these two directions of folding, you will feel there is more resistance and spring: this is an indication you are folding across rather than with the grain. Papers with a less obvious grain include recycled paper, handmade papers, or paper made with fibres that are equal in both directions, such as wet-strength tissues, intended for repairs.

The simplest folded book uses a rectangular sheet of paper. Take a sheet of cartridge; fold it in half, and cut it lengthways (1). Mark off the required size of the page at one end and then concertina-fold along the length (2). Make as many lengths as you like. You can join one length to another by making a 1cm (⅜in) tab at one end for joining, using PVA glue. Leave this to dry, weighting the paper under a book.

You can experiment with the concertina format further by using different folding methods on rectangular or square paper. Fold any sheet of paper in half lengthways; open it and then fold it in half and half again widthways. Fold in both directions to ensure a crisp fold that can move backwards and forwards. A bone folder is useful for this (3).

Cut or tear along where the solid lines are indicated and then concertina along the folds until the pages for the book are formed. Experiment with different papers and numbers of folds in the paper (4).

1.

2.

3.

4.

A more conventional book can be made as a one-section book with a soft cover attached to the outside. The format of the book will depend on the grain direction of your paper. Fold the paper in halves, quarters, eighths and so on until you reach the required size. Keep the spine fold parallel with the grain direction to avoid unwanted creasing. In this way, you can make a section from one single piece of paper. If making larger page sections, you will need to use pre-cut paper and then make the fold at the centre of each page for the spine.

1.

Once you are happy with your section, slit the folded edge at the fore-edge and the fold of the tail and head almost to the centre. This will allow you to keep the pages together for sewing and trimming (1).

Taking your section, pre-prick down the centre fold with a needle or bradawl, to make an odd number of evenly spaced holes. (A small book, such as an A5-sized one, may only need three holes, while a larger, folio-sized book will need as many as seven or nine.)

The easiest way to mark the holes is to make a piece of paper as a measuring strip, cutting it to the same length as the spine. Fold this in half and continue folding it until you have the correct number of points. Now fold it in half lengthways; place the V of the measuring strip inside the fold and prick through the measuring strip and the fold of the section (2).

2.

Take a length of thread, approximately two and a half times the length of the fold, and thread the needle by passing it through a short length of the thread to prevent it from slipping (rather than making a knot, which would enlarge the holes) (3).

Remove the measuring strip and sew, starting at the centre, working firmly and pulling the thread in the direction of working to avoid tearing the paper. After sewing, tie off again at the centre, over the long centre stitch (4).

3.

4.

You can further trim the head, tail and fore-edge to neaten the edges, marking the edge carefully with a carpenter's square and trimming with a knife. Cut carefully through a few pages at a time, or trim on a guillotine.

For single-section books, a simple cover can be made, using turn-ins and flaps. Measure a piece of thick patterned or coloured paper. It should be the same height as the section or spine of the book, but three times the width of the book. Fold the paper in half lengthways. Place the spine of the paper section against the fold, and mark where the fore-edge comes. Fold the flaps at the ends around the first and last leaves of the book. You can glue or stitch these in place if you wish (5).

5.

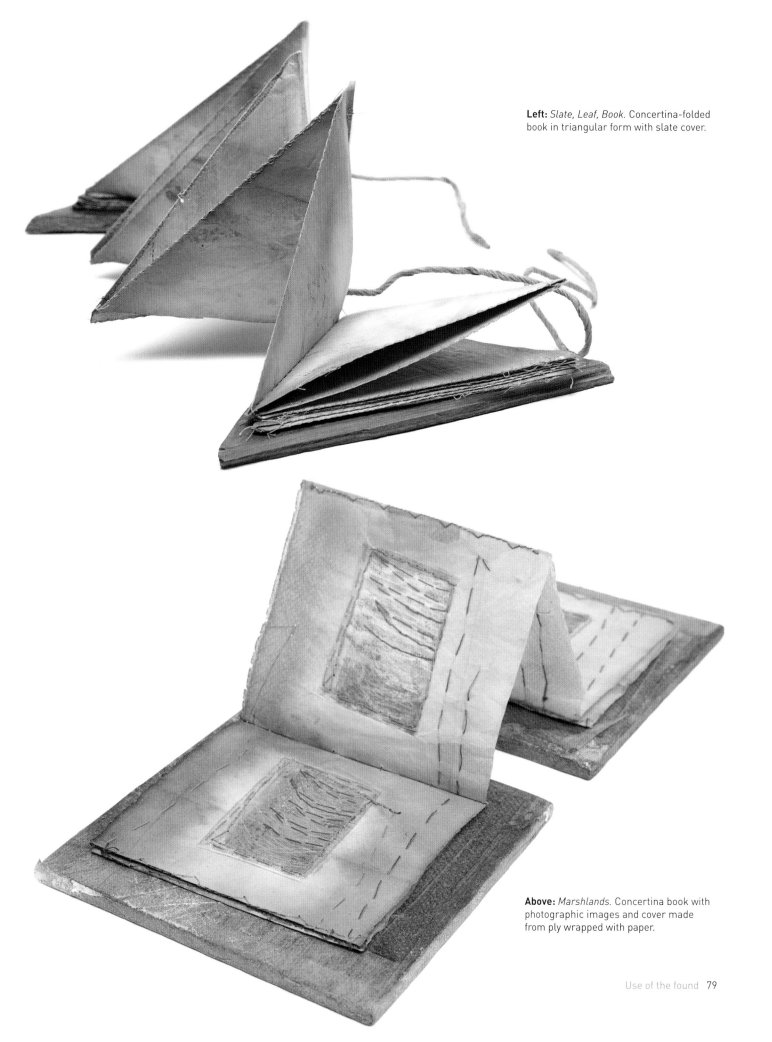

Left: *Slate, Leaf, Book.* Concertina-folded book in triangular form with slate cover.

Above: *Marshlands.* Concertina book with photographic images and cover made from ply wrapped with paper.

Altered books

An alternative to making a book with found papers is to create an 'altered book'. Starting with a book base, the artist tears away pages and then adds his or her own creative expressions through painting, collage, photo-montage, writing and stitch. Find a second-hand hardback book that has at least 100 pages. Make sure the pages are made from a reasonable quality of paper, avoiding ones with thin or glossy paper. To help you get over the idea that books are for reading and not for tearing up, make it a policy to use found books, or set a maximum price you are willing to pay.

Think about how you are going to start your book. Look through the pages and mark those with interesting text or images. It's useful to have a practice book to use if you want to try something out. As you work, ideas will pop into your head and you need to make a note of them so you don't forget. Keep a few Post-It notes or a notebook to hand for this purpose. This way, you can start to formulate your ideas before actually making a start with paints, glue and stitch. Think about how you may alter the cover and the pages.

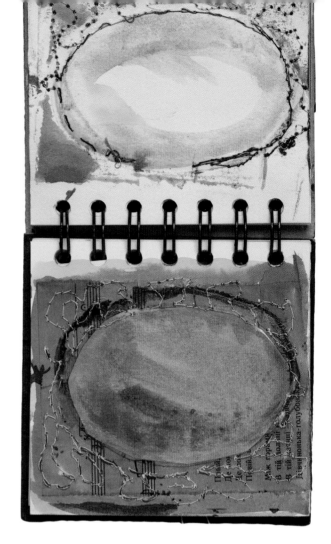

Above: Sketches that led to the finished piece, left.
Left: *Music, Poetry and Eggs.* This book, found at a thrift store while I was teaching in Colorado, was added to daily with old bits of text and images given to me by students.

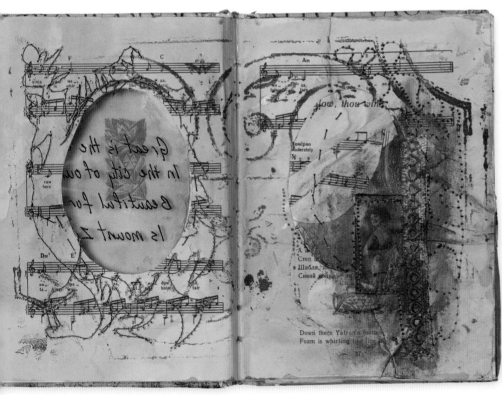

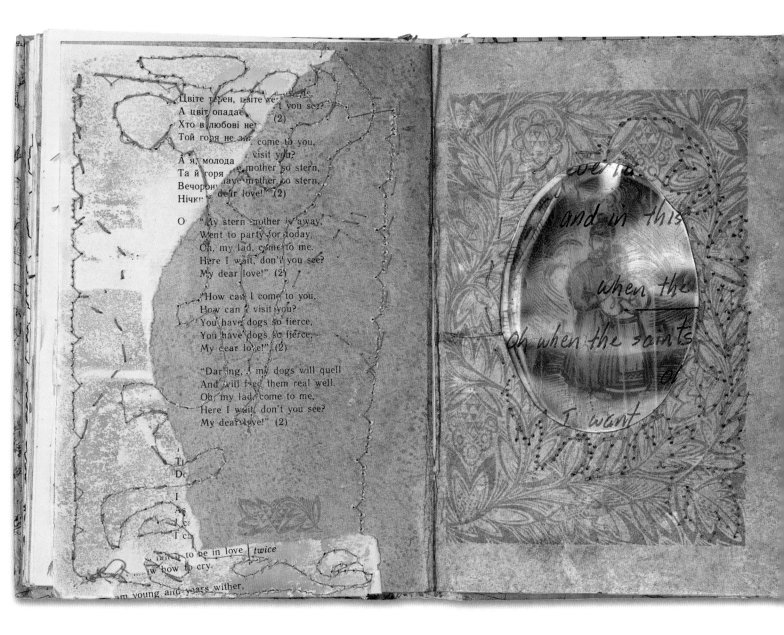

- Look at the structure and content of the book. Why have you chosen it? Does the subject matter act as a stimulus for ideas or is the visual imagery the most important aspect, or a combination of both?
- Start by tearing or cutting out some pages. Go through the book from front to back, trying to remove pages at regular intervals. This makes more room in your book and creates spaces in which to insert things.
- Collect images, objects, materials and equipment that you feel that you would like to use, such as old maps, family photos, tickets, newspaper cuttings, magazine pictures and fabric and paper scraps.
- Think about colour and texture to help create a mood for the work. Colour and pattern remind us of the places we've been, evoking special memories or even seasons of the year. Texture, in the form of fabrics, handmade paper or stitch, can give the pages a tactile quality.

- Cover the pages with a wash of diluted acrylic paint, ink or dye. Different types of paper accept paint in different ways, so be careful not to add too much water. Mask any text you wish to keep free of colour with paper or low-tack masking tape.
- Collaged images and text can be used to alter the pages of books. When cutting for collage, use sharp scissors and a very sharp scalpel and use a good cutting mat behind the pages. Cut slowly.
- Extra pages can be inserted. Cut a page back almost to the centre fold so that it is only about 3cm (an inch or so) wide. Another page can be fastened to this flap with glue or, better still, you could stitch it in place with decorative thread. Old photos, fabrics, letters, documents, tickets and so on can be fastened into the book in a similar way.
- Try different printing and marking techniques on the pages. You can use sponges, crumpled paper, random shapes, letter shapes, found objects and so on. Create a textural background with a wax-crayon rubbing, and then paint over the rubbing.
- Create pop-up sections or windows. It is better to strengthen the pages that are going to be used by gluing two pages together. Create windows by cutting through to other pages. These can be stitched and bound.

Below: *Book of Changes: Stamp Collection.* A section of a book was cut into four pieces and the edges were rebound using a Japanese bookbinding technique.

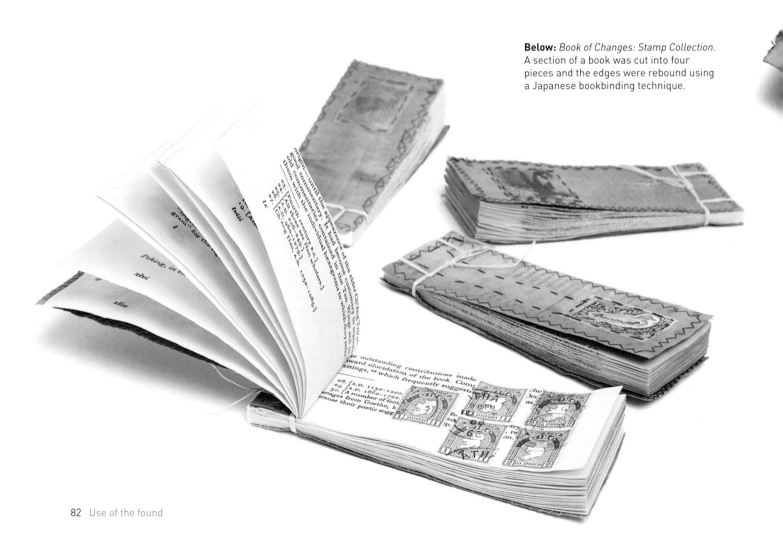

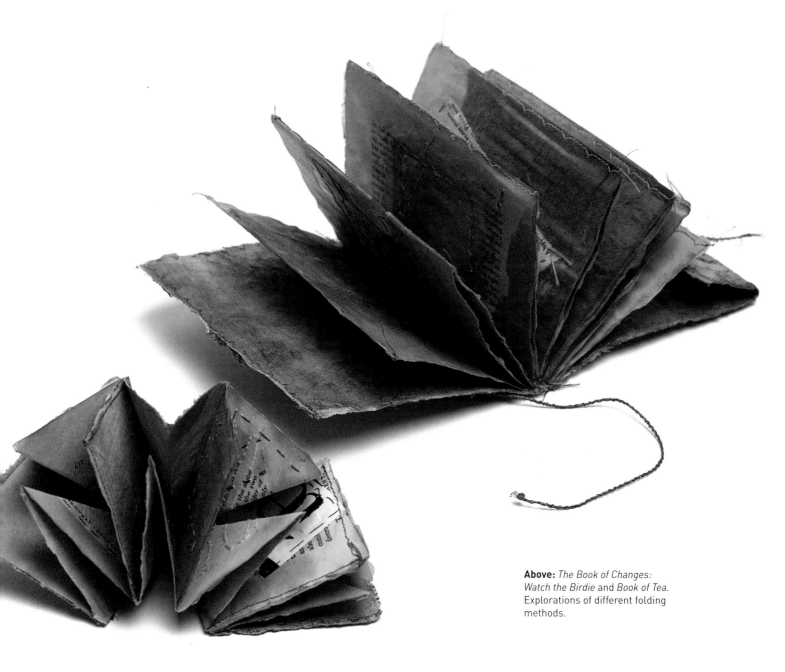

- The book can become sculptural. It does not have to close. It can be completely taken apart and then reconstructed to create another form.

A while ago I was given a copy of the *I Ching* (the *Book of Changes*). For over a year now, I have taken pages out of the book and made them into new 'book forms'. The content of the pages informs the next structure, as with *Book of Tea* and *Watch the Birdie*, which uses pages looking at the meaning of birds in the telling of the future. This is a continuing project, which I dip into on a regular basis, coming up with a variety of book forms to present my ideas.

Natural and man-made materials

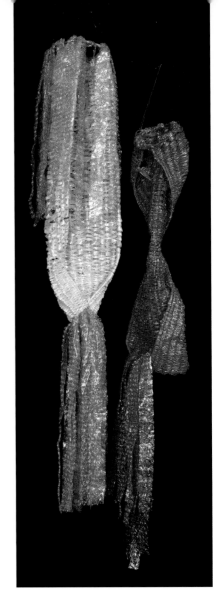

Discarded matter can be transformed into all kinds of different objects; the cycle of accumulation and rapid disposal of possessions leaves us plenty of material to work with. The significance of using 'found materials', as opposed to recycling or reusing waste, lies in their perception by the artist and how they may be interpreted. Many textile artists use natural and man-made waste materials as social commentary.

Textile artist and former Head of Creative Arts at a secondary school in Kent, Sue Pritchard, describes her relationship with plastic waste: 'The school I worked in is very lucky to be in a beautiful rural setting with extensive playing fields which are liberally sprinkled with waste-paper bins. Despite this, staff are constantly nagging students not to drop litter. Every so often a craze appears in school that seems to take over everything. Suddenly everyone seemed to be sucking sherbet from brightly coloured plastic straws, and then dropping the straws all over the place. It got so bad that they were banned from school, but it didn't work. Then I had the idea of asking the students to give me their empty straws, promising to make an artwork from them. Strangely, they were able to bring the straws to my one collection point in the art department, though unable to put them into one of the many bins all around school! *Candy Colours* is the result of one of those crazes. I had to solve the health and safety problem of straws dirty with sugar and the spittle of several hundred students (I did) and find a way to use such short lengths. Weaving and patchwork gave me the answers, though I'm not so happy with my use of staples.'

The colour and form of Sue's work is often dictated by the materials and techniques she uses. By using textile techniques to manipulate waste plastic packaging, Sue draws attention to the pollution that contemporary society produces. Plastic is difficult to recycle and is still mostly non-biodegradable. Scientists have found it in the deepest oceans and uninhabited regions, and it is now in the food chain.

The combination of the natural and the man-made can give rise to interesting new forms. In *Sprouter*, by Veronica Tonge, an old coconut shell is combined with lurex threads and a pink plastic bracelet to give rise to an object suggesting growth in its seed-like form. The shell of the coconut has been drilled with small holes and threads drawn through and tied off.

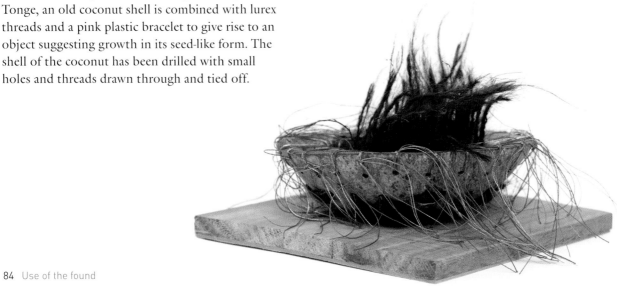

Tools and materials

Man-made materials, including many plastics, can be used simply because they create another interesting textural surface for decoration and detail. Whatever your reasons for use, consider how you may transform your found object through the manipulation methods common to textiles.

Useful manipulation tools to keep to hand include scissors, knitting needles, large-eyed darning needles, crochet hooks and wire cutters.

Experiments with natural and man-made finds

- Explore the possibilities of stitching plastic onto your textile surfaces. Bits of shiny plastic, such as sweet wrappers, can be inserted and show through areas of heavier stitching.
- Alter the materials by rolling, twisting, shredding, tearing, pleating and folding.
- Look at interesting surfaces to attach or tie things to, such as garden mesh, road-safety mesh, open-weave fabrics, sticks or any object with large holes or an open mesh.
- Weave with brightly coloured plastic bags and unusual materials, such as Lurex, plastic wrapping paper, string, ticket tape, ties, tights, felt and paper.
- Use found objects to set up warp threads to weave into (hoops, boxes or picture frames).
- Explore means of attaching one surface to another, including tying things on, stapling, lacing, knotting or plaiting.
- Think about scale and shape. Cut mesh into triangles, squares and other shapes. How does the addition of other elements change the mesh? Do areas pull into different shapes? Does the surface bend?
- Crochet or knit with giant needles, using plastic bags and fabric cut into strips.
- Bear in mind the qualities in the materials – shiny, dull, silky, matt, sparkly, rough or smooth.
- Think about working outside, suspending plaited forms and objects from branches. Tie and wrap fabric to sticks and branches. Be aware of the need to work sensitively and remove items after a short period, before they can do any damage.

Opposite, top: *Pretty Pink Plastic* (Sue Pritchard). These knitted forms, reminiscent of sea creatures, are made with plastic bin liners.
Opposite, bottom: *Sprouter* (Veronica Tonge). The loose ends of the threads in this piece suggest movement and growth.
Left: *Candy Colours* (Sue Pritchard). This piece is made from plastic sherbet straws.

Health and safety

Consider the following safety aspects when using tools with plastics and man-made materials:

- When heat-treating any plastic-based materials, use a mask and work in a well-ventilated area.
- Always work on a fireproof surface and near a source of water.
- When melting plastic with an iron, place the plastic between two sheets of baking parchment and check the surface regularly.
- When stitching, use as fine a needle as possible on the machine or for handstitching.

Found objects can also be used as moulds for creating new works. Susan Cutts uses her own handmade abaca paper to create repeated forms that centre on concepts of our relationship with clothing. Susan often makes a paper mould over the object she intends to use as a base, cuts it off, and then pieces it back together with stitching. It is next coated in wax (to prevent water penetration), and she then works over this mould with another layer of paper. Once the paper is dry (she works with wet paper, so does not use glue), she tears away the inner waxed mould, leaving an outer layer entirely formed from paper. This is the basic process she used to produce *Stiletto*, a massive 400-piece installation, and *Footsteps*, a cast of children's shoes that she made in coloured papers. After a while, she started working directly over each shoe, and although there is a high level of shrinkage with paper, she managed to remove the inner shoe without damaging the outer, paper shoe. Susan says: 'I am fascinated by the relevance of dress to both the wearer and the observer. In *Stiletto* my starting point was pain through dress. Lotus shoes were the first shoes I made and from these I progressed to a shoe familiar to the 20th and 21st centuries – the stiletto. A little research revealed that the pain was unimportant to the wearer; instead, the mention of the stiletto led to reminiscences, dreams and disappointments. I used second-hand shoes bought at boot fairs and worked with about 20 different pairs. While working with them, I appreciated how a shoe can be endowed with so much expectation. It was obvious that some shoes had been worn till they almost fell to pieces and yet others were hardly worn, each shoe telling a different story many times over. Each shoe a portrait of its wearer... I made this a multiple piece because once I started making the shoes, the making got easier with practice and I felt I couldn't stop because there was always another story to tell. I didn't see the piece as a 'whole' until the first exhibition and I was amazed at how they transformed when en masse. Working from a normal-sized studio means large pieces are never seen by me until they are exhibited.'

Fairy Tale was inspired by a junk-shop find of a silk petticoat which had never been worn and was wrapped in its original tissue. Susan uses the image of the dress to examine how we invest emotionally in clothing and the result is her version of a Disney 'Snow White' dress – a laced top with tutu-style skirt. The dress bodice is made in one piece; the skirt has three layers and has been creased to resemble crumpled silk or net. Another method Susan employs for her dress pieces is to make a basic paper body mould, on which she creates the dress, similar to making a toile in dressmaking.

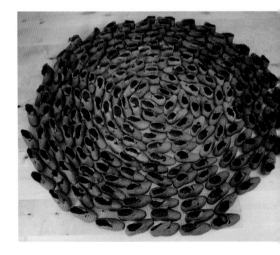

Above: *Footsteps* (Susan Cutts). Cast children's shoes in paper.
Right: *Fairy Tale* (Susan Cutts). The 'dream of a white dress' in paper.

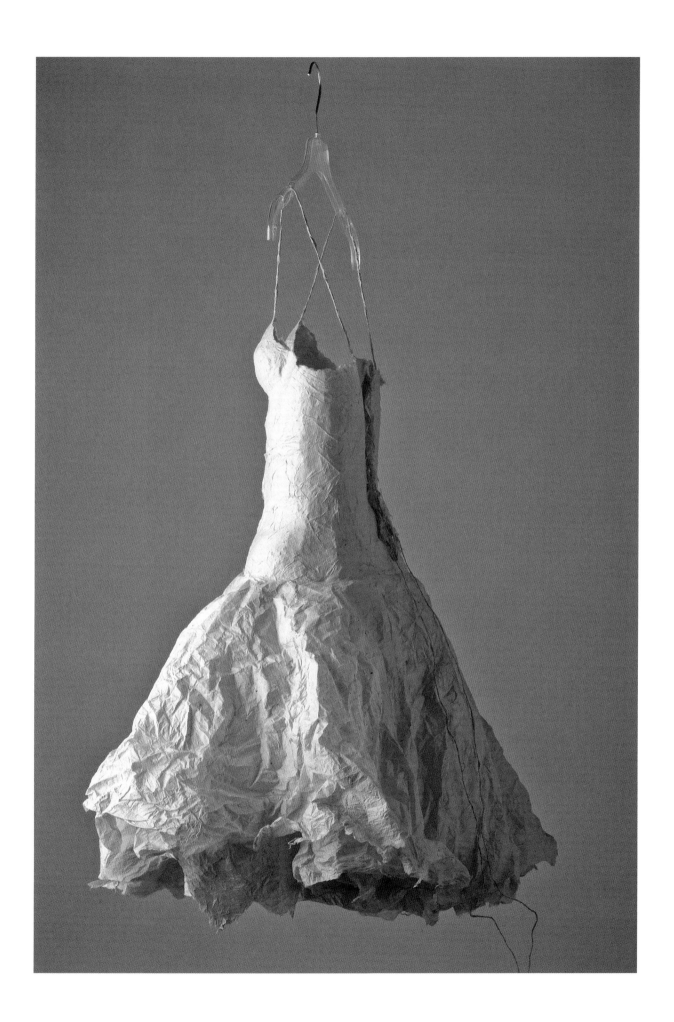

Unusual frames

Artists have long made use of found frames and boxes in which to arrange smaller works. Painted and collaged boxes and frames provide a structured background in which to arrange a collection of small, related textile pieces. This enclosed background offers scope for unusual compositions illustrating particular themes or subjects.

Decoupage technique

An ideal way to alter existing found frames is to use techniques based on the Victorian method of decoupage, which requires little in the way of materials and equipment other than collected papers, images, scissors and glue.

1. The frame you use may need tidying up. Remove traces of old paint with coarse sandpaper; lightly sand the frame with fine paper, and then wipe clean with a damp cloth.
2. Paint the frame with craft paint. Concentrate on painting the sides and inside of the opening. Areas you intend to collage do not need painting. Apply the paint with a soft brush and try to avoid painting over the same area more than once, as this can leave an uneven surface. You can also apply paint with rags or sponges for different effects.
3. Once the paint is dry, you are ready to attach your images and decorated paper. Cut or tear your shapes out and lay them on the frame where you choose, to get an idea of how they will fit.
4. The choice of adhesive will depend on the surface on which you are mounting your papers. Either white craft glue (PVA), diluted to a creamy consistency, or wallpaper paste will be suitable for most projects. When using wallpaper paste, mix it to a thin consistency and apply it to the frame where you want your object to sit. Next, add the image and then smooth it in place. White craft glue should be applied directly to the back of the paper or image.
5. When the image is in place, carefully wipe away the excess glue with a clean, damp cloth, pressing out any bubbles that might form on the paper.
6. You can add further layers of paint at this stage. Pay close attention to the edges of the frame and any inside opening edges. You can do this either when the frame is still damp with the decoupage or when dry, which will give it an antique or distressed look. You could also sand down the dry frame to distress it further.
7. Cover the whole frame with the diluted craft glue or water-based varnish. Make sure you cover the sides of the frame as well. This will help protect it and give it a glossy finish. Use matt varnish if you do not want it shiny. You can also add a little dye or ink to the varnish, to give a more cohesive feel to the frame.
8. To make the frame more durable, you can seal it with several coats of picture varnish.

Opposite, top: *Small Sins.* Stitched text and images inserted into found frames, wrapped in the same text.
Opposite bottom: *Indian Diary: Sacred Cow.* Waste materials from the workroom floor, collaged and stitched onto canvas.

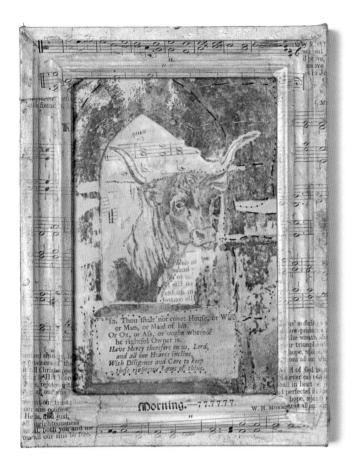

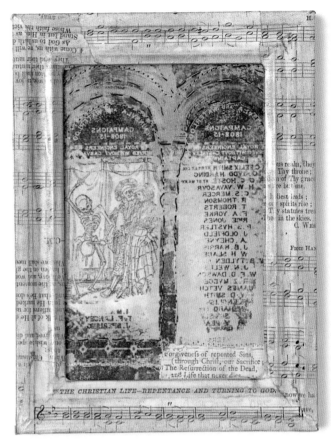

Your frame will be more personal if you add your own colour to the images and papers applied to the surface. This can be done with coloured pencils, inks, paints or dyes. In *Small Sins*, I have used a variety of small glass frames and old cigar boxes to create integrated works, in which the image and text from bibles and hymn books carries through to the frame.

Old stretched canvas can make an interesting background for textile collage. This can either be painted or coloured with dye before you stitch, or you can decorate it with patterned paper and fabrics. Simply 'paint' your stretched canvas or canvas board or panel with a mix of white glue and water, and then lay down the tissue, carefully pressing out any bubbles. When it dries, you can continue to collage directly on top of your background, adding layers of stitched fabrics and papers as you go. The *Indian Diary* series uses the discards saved from my workroom floor which were then collaged onto the canvas. The 'drawn' elements were free-machined onto fine paper with a very sharp needle before being pasted down.

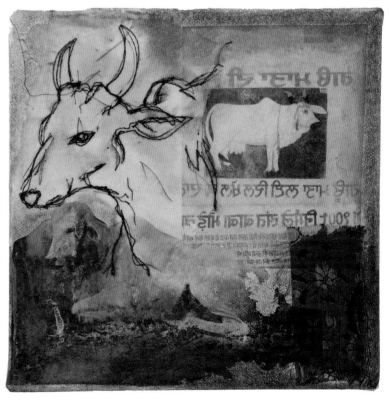

Alternative options for presenting work

Look at unusual ways of presenting your work by seeking alternative framing or display devices. Three-dimensional forms require particular consideration. Penny Burnfield's *Holotypes* reflects the artist's continued interest in collecting and categorization. The associated ideas and title come from the science of biology and approaches to recording. An 'original' specimen is always described as a holotype, as part of the process of categorizing a new species. These strange new forms, made with paper, felt, yarns and paints, sit in glass jars, which Penny found in charity shops.

Found frames from the world of science and administration played a similar role in some of my pieces. *A Little Culture* is framed in Petri dishes, as used for growing cultures during scientific experiments. A play on words, the tiny textile fragments contained in the dishes ask to be examined more closely, identifying their importance of as part of the visual 'culture'.

The presentation or 'frame' becomes part of the concept. Over many years of administrating projects, I have found many discards I can reuse in this way. Old slides have been strung together and worked with stitch and paper to create small pictures. When learning to use a computer the first time and coming to terms with the keyboard and screen, I found sucking on boiled sweets eased the strain. The resulting sweet wrappers and waste printed paper were turned into little 'bugs', which were then framed in old CD cases.

Above: *Bugs in Boxes.* Bugs created from white paper and sweet wrappers framed in empty CD cases.

Above: *A Little Culture.* Tiny stitched fragments in petri dishes.

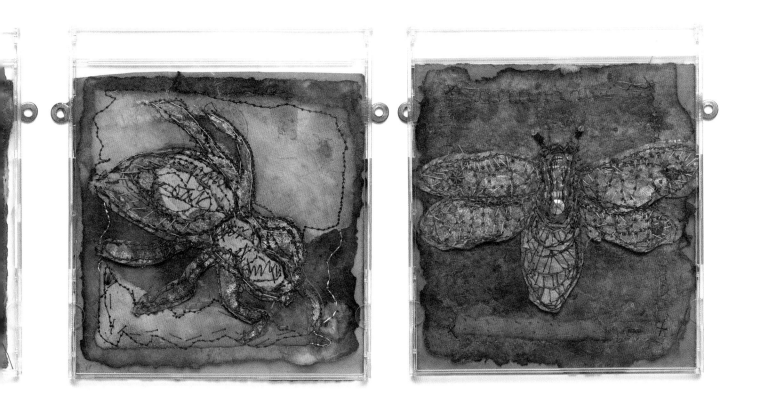

Below: *Holotypes* (Penny Burnfield). Scientifically presented creatures made from fabric and paper.

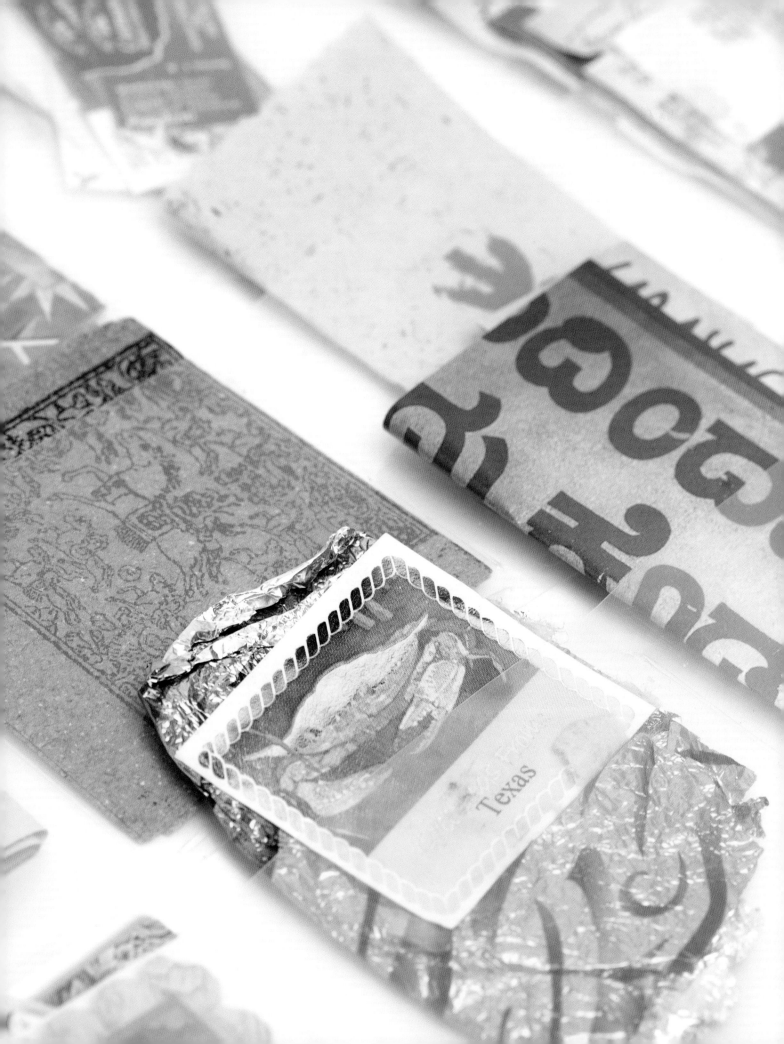

3 Magpie of the mind

Don't be intimidated by rules. Matisse said, 'Great art makes its own rules.' Every rule is waiting to be broken. Value your individuality. Creativity is finding different ways of doing things. Inspiration can be found just about anywhere, even in the most everyday situations. Be inquisitive; ask questions, and set yourself simple challenges to start your observations. Like a magpie, collect things of interest from around you, noting down what makes these things interesting to you and finding your own way of recording your interest.

Research

Primary source material usually comes in the form of drawings (accepted in its widest sense – drawing, painting, collage, notes and so on) and photographs. This research is rarely confined to the studio and the textile artist should gather images and write about experiences relevant to his or her practice. Most of my recording and observation come from objects collected, notes taken and drawings made as part of my footfalls. These are things connected to my 'immediate' environment as I walk, cycle and use public transport, and my relation to the changes in that environment.

To understand the 'bigger picture', I exchange ideas with other professionals, attend workshops, read literature and travel. Travel really can broaden the mind. A research trip to India was undertaken to identify my Romany roots within the broader historical context of the heritage and culture of the northwest region of India. Materials with which to work were collected from the street. I kept notes and drawings in a daily journal and took photographs of architecture, street scenes and people, as a means of making visual links with the past and present.

Other explorations include examining secondary sourced material, from museums, exhibitions, books, magazines and the Internet. These sources are equally important as a means to inform, inspire and place your practice in context. My local museum, the Maidstone Museum and Bentlif Art Gallery, is a rabbit warren of interesting objects, including a stunning Japanese collection and a costume gallery. I regularly sit there and make sketches, and I encourage my students from the neighbouring adult education centre to do likewise.

Opposite: Plastic pockets containing fragments of found papers gathered on my travels.

Observation and recording

It is up to you how you note things and whether you use drawings, notes or photography to help 'fix' those ideas gained through observation and research. Use whatever you feel is right, but keep a record; it is an essential part of the creative process. A notice board in your workspace makes a useful place where you can keep collected information as well as working ideas. Folders with various sizes of plastic leaves are a practical way of keeping visual references torn from magazines and newspapers. Tiny finds, gathered as you go about the stuff of everyday life, can be kept in clear-plastic slide pockets. Each pocket may contain something that is strangely beautiful, unusual or odd that can provide a miniature trigger for an idea or project.

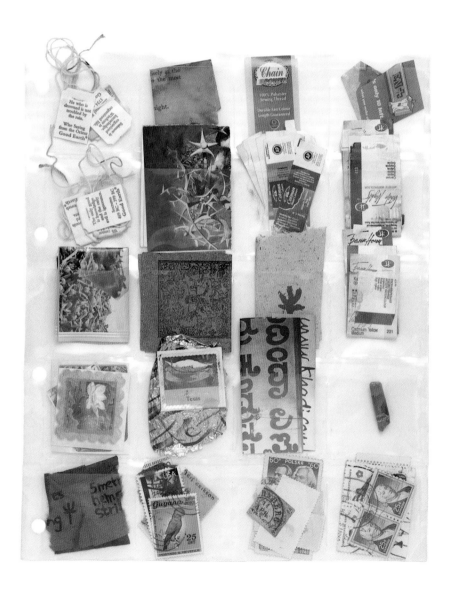

Left: A collection of found papers, stamps and printed matter displayed in plastic pockets.

Using the camera

Exciting images can be found in the abundance of magazines, books and printed media that surround us, but these are never as good as the images you take yourself. You can use the camera to record information and develop additional notes to accompany your research. Photos support and inform the development of your ideas and can be cut up for collages. Computer misprints of photographs are useful tools when drawing, as they can be cut and torn to create compositions and can also be incorporated into your drawings.

A single photo is rarely enough to fully understand a subject. Investigate through the lens. What drew you to the subject? Take photographs from several different angles and record any specific details of texture, colour and pattern that might be useful. Be critical of what you see and record as part of the design process. Elements of design are covered at the end of this chapter, but there are some key points to consider when making your own photographic records.

Light and colour

What is the time of day and what are the weather conditions? Seasonal variations, times of day and changing weather conditions alter natural light and how we read the colour, tone and texture of our subject. There is a row of poplar trees just outside my bedroom window. The view is pleasant as we look over the downs, but not exceptional. However, in the late afternoon, just after a rainstorm, the clouds break and bathe the trees in a warm light that contrasts with the blue-grey of the skies, and the scene truly becomes nature's theatre.

There is no easy way to control your light. Lingering shadows and a softening, varied light are more typical at the beginning and end of the day, while the bright sunlight of midday sharpens colours and highlights detail. Artificial light can be used to emphasize texture on patterned surfaces and create interesting shadows when angled from one direction.

Below left: Signs at a fruit and vegetable shop in Grand Junction, Colorado, USA.
Below right: Poplar trees in the late afternoon (view from my bedroom window).

Pattern, shape, texture and line

What is the most interesting aspect of your subject-repeated patterns: the colour or the silhouette? What would happen if you photographed it at really close quarters? Consider the angle from which you shoot your subject. The gardens at West Dean, where I frequently teach, always hold surprises. Lying down on the ground in early morning frost, I captured some amazing patterns and texture on the leaves and plants. Sometimes, it may be necessary to take a shot 'blind', without looking through the lens to get the right angle. This can give you some of the most unexpected but rewarding shots, such as the light bringing out the veins of leaves.

Look at the visual texture of your subject, such as surfaces of fabric, the bark of a tree or colours in stone, and learn to take shots using the close-up facility of your camera. Consider what is in the frame, looking at rhythms and patterns in line, the horizontal of a landscape or vertical patterns within buildings. In India, my small point-and-shoot digital camera enabled me to take some quite dramatic shots. It was unobtrusive, so often people were not aware they were being photographed, therefore helping to create a more 'natural' feel to the images. The camera's setting adjustments gave plenty of scope, allowing for close-ups and shots in low-light conditions. Use the camera to 'look' rather than merely 'see'.

You can adapt your photos with even the most basic photo-editing software on your computer. Remove any unwanted areas in the image; manipulate colours and shapes to aid with the development of ideas. But technology and speed, while useful, aren't always the most positive aids for your design process. Playing with printed images and photos, tearing, cutting, pasting, drawing and other hands-on processes can provide the flexibility and time needed to resolve your design ideas.

Opposite, clockwise: Pictures taken in India: worn surfaces on a Jaipur wall; a richly attired horse at a festival in Amritsar; fading text on a wall in Jaipur; a line of brightly costumed women at the Taj Mahal.
Below, left and right: Photographs taken in the gardens of West Dean College: alliums in sharp and soft focus, and verge-side plants against the sky on a cold morning.

Above: Working ideas using collaged lace and paper.

Keeping a sketchbook

Drawing remains, for me, the most important means of recording something observed or as the first step to thinking through my ideas. To draw something involves your commitment to observation, to making decisions and to drawing comparisons about the mark you make and its relationship to the page, your subject and your idea. Visitors to galleries are always drawn to the journals or sketchbooks of the artists, as they invite you into the hidden world of their creative mind, their personal journeys.

A drawing can be either of a given subject or abstract, such as a diagrammatic representation of a texture, shape or pattern. Drawings serve a variety of purposes when developing design ideas: as quick reference, a means of recording the world around you (nature, objects, landscape) or to communicate an idea where verbal clues would be difficult (plans and diagrams).

Draw for yourself, for personal use. Many people claim they can't draw, but making marks is about communicating, not necessarily about creating a fantastic piece of art fit for a gallery wall. A pencil can be intimidating for the novice, but you don't have to use one. Timid handling is not possible with chunky wax crayons, pieces of charcoal, oil pastels or even carpenters' pencils. The physicality of these drawing materials requires a particular type of handling, encouraging bolder, gestural mark-making. Using less conventional tools that you find around you can encourage a more playful attitude to mark-making. I often ask my students to draw with twigs dipped in ink or with charcoal attached to sticks with masking tape. Standing with paper taped to the wall or floor, you need to use your arm and body as you make your marks.

Facing a blank page can be a problem, even for the most experienced artist, so improvize. Stain or paint pages in a sketchbook first and then draw into them later, selecting a background colour that may suit your subject. Paint and draw in the pages of an old book or use textured paper. You can buy a wide variety of different papers today, but the 'wrong' side of old brown parcel paper works beautifully for charcoal or pastel drawings. The back of flip-chart paper, wallpaper or even newspaper can make equally useful drawing surfaces. If you feel your drawing is not working, does it matter? It really is only paper. You can cut it up for collage or repaint the entire surface and draw back into it.

Sketchbooks are successful because they combine different techniques and materials to express ideas. Collecting found images that help to explore ideas related to personal collections, text and memorabilia could be a good starting

point for documenting ideas. When travelling, I keep a journal as well as collecting items of interest along the way. I am sure I am not alone in being a magpie! Mapping your journey is a good introduction to the location and the changes in the landscape you see around you. I always have a small notebook to hand and the simple, quickly snatched sketches, taken through a train door or while sitting having a break, remain the most evocative memories.

Your drawing kit can evolve as you travel. A watercolour set or water-soluble crayons and brush, fine-line pens and a couple of pencils, along with a pocket-sized sketchbook (with good-quality cartridge or drawing paper), should be sufficient. A glue stick and small bag for your finds can also be useful. Most other materials you can find on the way, or improvise. Railway stations, airports, in fact most stopping places as you travel, will have shops that sell paper, pens and the like. It can be part of the challenge to find new resources – use local magazines and leaflets for collage, food bags and wrappers as drawing surfaces. Plastic knives and lolly sticks make good glue spreaders and mark-making tools. Locally found materials used in sketches allow for spontaneous responses to new environments, and this can result in exciting possibilities for work.

Consider different surfaces to be painted, collaged and stitched, and amass relevant imagery you can work with:

- Old books, manuscripts, photocopies, torn paper, text.
- Tickets, postcards, stamps, envelopes.
- Card, fabric, lace, string, leaves.

Think about working on different surfaces and the quality of the printed materials and mark-making in relation to your subject matter:

- Use a range of media, such as pens, pencils, crayons, inks and paint.
- Collect items such as sticks, plastic cutlery and straws to make marks.
- Use collage as a starting point, incorporating fragile, heavy, transparent and opaque materials.
- Explore colour applications – tea bags, coffee and even clay and plants can be used to stain pages.

Below: Pre-painted sketchbook pages with simple line drawings in ballpoint pen.

Sketchbook starting points for stimulating ideas

- Experiment with the types of sketchbook you use. Large ones are good for using at home and give you plenty of space for diagrams, linking images and gestural drawings. Small sketchbooks are easier to carry around for recording on the move. Spiral-bound sketchbooks are flexible and can take a lot of wear and tear. Thicker cartridge paper is usually a good general-purpose surface to work on, and is more versatile than watercolour paper for most things.
- Stain each page with ink or paint, relating your colours to your subject or chosen theme, if you wish, and then work over the coloured backgrounds when out and about.
- Take a large sheet of paper and make a concertina fold (see page 77), creating a small folding sketchbook for use with a theme, such as small natural finds, patterns in the urban environment or even small treasures in your home.
- Use text as your starting point, perhaps the headline from a magazine or part of a poem.
- Try filling a small sketchbook by working on a page a day. Add to the pages, tear them, stitch on them, and make prints.

Below: Jersey sketchbook. Selection of machine-stitched, torn and stained pages.

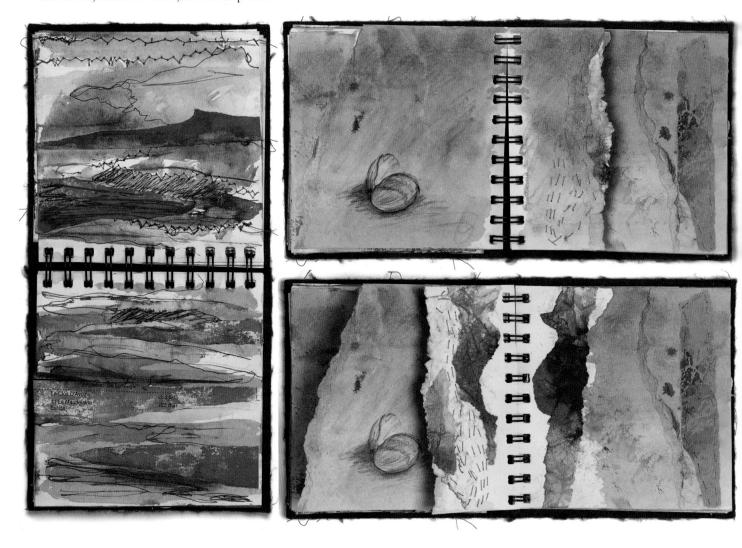

Developing drawing

Drawing should be tackled in the spirit of exploration – analyse, record, select and discover new approaches to working. Experiment with the way you make your drawings.

- Make several studies of a group of patterned objects, using coloured pencils or paints.
- Find areas of interest with a mini viewfinder. Old slide mounts or cellophane windows from envelopes are good for this, or you can make your own viewer by cutting a rectangle in card, or using two L shapes (shown below).
- Create a collage from the pages of a magazine, paying close attention to textures and marks. Photocopy the study and then make a drawing in the tones of the photocopy. As suggested above, you can take smaller areas of interest and make further studies, setting your own rules, such as using a limited colour range, creating line studies in ink or making further collages.
- Using a fibre-tipped pen, create line drawings of a group of objects or a landscape, using both your left and right hands. Increase the scale of these drawings on a photocopier and then make further drawings from these.
- Try drawing without taking your pen off the page.
- Fold, crease, crunch and tear paper. Glue different paper layers together and then draw on the top layer with the medium of your choice.
- Create drawings using rubbings and prints as a starting point.
- Layer your drawings. Start with a general loose wash of your subject and then draw on top with dry media. Draw with a pen (waterproof or non-waterproof) and then add layers of tissue with glue. Leave the layers to dry and then make further drawings on top.
- Photocopy drawings and found images; make a collage and glue paper tissue on top. Work back into the surfaces with drawing and paint. This is a good way to use up your old computer prints.

Above: Line-and-wash drawings.
Below: Using a mini viewfinder to find an area of interest, then cutting it out.

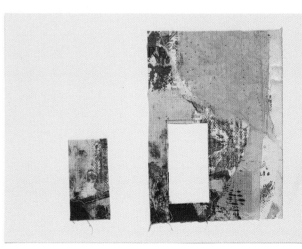

The elements of design

Elements of design are the visual tools you use to make a piece of work: line, shape, space, form, colour, tone and texture. Realistic studies with recognizable elements are often regarded as 'good', depending on how well you represent them. In discussing a painting, for example, you could say it would be stronger if the horizon were higher or the sky more intense. In experimental textile work, the elements of design apply to both representational and abstract works.

- **Lines:** curved, straight, thick or thin, lines can move you into and around a study. Straight lines are more static than curved. Diagonal lines can add excitement, taking you across the work. Horizontals and verticals can create tension and suggest form.
- **Shapes:** think small, medium and large, for variety, as shapes of the same size could be boring. Shapes can be geometric (square, triangle or circle, for example) or organic and the different types usually co-exist in the same study.
- **Space:** textiles or paintings have height and width, and you fill the resulting space with shapes to make a study. Shapes and objects are positive space; the space between objects is negative space. Both are important and relate to each other.
- **Form** provides a third, illusionary dimension to your space and shapes; through shading and the use of perspective, a square becomes a cube or a circle becomes a sphere.
- **Tone** concerns the relative lightness and darkness of your subject. If your study is not working, the tonal range – light, medium and dark – can often be the problem. Many textile artists look at colour and often fail to see the relative tones of their study.

Colour

Our perception of colour is based on our own experience or reality. Colour is always moving and changing. It is never fixed; it is transient. Colour not only suggests the content of a piece of work, say, a sunny landscape scene, but can also express a mood or suggest an emotion. There are recognized rules of colour theory explaining how the different hues relate to each other, but despite these, colour is a very personal choice. We respond emotionally and intuitively to colour. Yellows describe a warm sunny day; we are 'blue' with cold. However we respond, there should be some form of dominance in all aspects of colour usage: where everything is equal, nothing is important and the study can be boring.

A good way to develop your instinctive understanding of colour and design is to keep a colour diary. Glue collections of colours from magazines and fabrics into various groupings and experiment with combinations of colours.

Right, top: Sketchbook pages: colour exploration in paint and collage.
Right, bottom: Sketchbook pages: working ideas in three panels, with a stitched sample.

consider Translucency
& rich layers
cheesecloth
Buried fabrics
archway.
Soak fabric in
washing soda &
see if I can get
a print from flower
by placing in a
press.

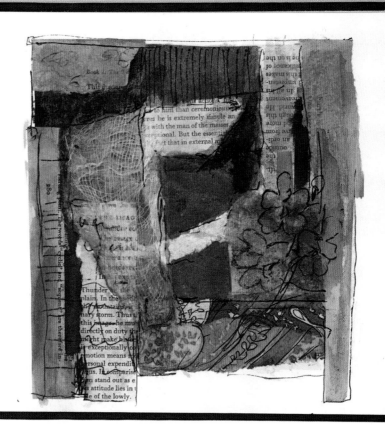

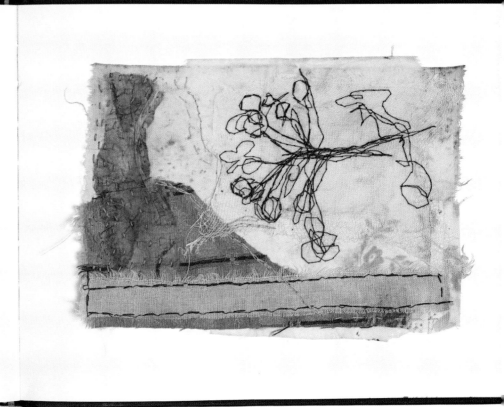

Colour and design: some key words

Hue: the name of a colour (red, yellow, blue and so on).

Chroma: the intensity, purity or saturation of a hue.

Tint: a hue mixed with white.

Shade: a hue mixed with black.

Temperature: a term used by artists to indicate the colour, relative to red (warm) and blue (cold).

Primary: red, yellow and blue.

Secondary: the colours green, purple and orange, obtained by mixing two primaries together.

Complementary: the complementary of a primary is the combination of the two remaining primary colours. Yellow and blue, mixed together, make green, which is opposite on the colour wheel, or complementary, to red. Mixing complementary colours produces deep, intense darks.

Texture: this can be added or perceived. You can create texture through modelling with pencils and drawing media (curves, lines, dots and so on). Make rubbings or print into dye and paint, as well as using brushes and sponges. You can also make physical textures, gluing on paper, fabric and found materials to make collages.

Proportion and scale: change scale and combine shapes of different sizes in relation to each other to make a 'pleasing' design.

Unity and variety: the repetition of colour and shape can unify a study, helping it work as a whole. Large or small circles, worked on a grid, or repeated squares can lead to interesting compositions. Variety is also needed to stop studies becoming too boring. This can be achieved with differences in colour, shape, texture, edges and tone to break the 'unity' in places.

Contrast: 'to compare so as to point out the differences; set against one another'. Light against dark or a bright colour in an otherwise neutral study can provide the necessary contrast. Strongly contrasting tonal or colour values can allow a textile or painting to be seen from across a room. You can create conflict deliberately by using colours that jar, leaving edges unresolved or including unpleasant imagery in an otherwise peaceful study.

Rhythm/repetition: created by having elements of repeat at intervals, or similar shapes, colour or texture.

Balance: this is the key to a successful work; if it does not 'feel right', we need to resolve the problem. Symmetrical balance has identical parts on each side of a central line. An asymmetrical study has different parts on either side of the central line. Shape, light and dark, colour and form can all affect how 'visual weight' is perceived. Small and large shapes can change the feeling of balance in a painting or study.

Emphasis: establishing a place for the eye to go, a focal point, centre of interest or point of emphasis. This is achieved by bringing many different methods and techniques together. Lines can point you to a place of interest. Tonal contrast, interesting shapes, a theme or narrative in your work help to draw you in. You can design a 'format' or plan elements of rhythm, repetition, colour and shape or pattern to direct the eye around your composition to your area of focus.

Below: Sketchbook page: exploration of design format in collage, carrying the image across six panels.

Design formats

Strata: linear sections, vertical or horizontal, are good for landscapes.

Shapes: circle, square, triangle and so on; note that portraits and still-life studies often work well with the main centre of interest contained in a triangular format.

Diagonals: a slant to your study gives motion and excitement, helping you to move across the work.

Cruciform: the centre of interest is where the cross intersects, which can be high or low on the design plane.

Low and high horizon: low could emphasize a dramatic sky; high could draw the eye to fields in a landscape or a tree line.

Overall patterning: this entails weaving together shapes and forms, with no obvious point of interest, relying on rhythm, unity and variety to produce the desired effect; grids and interlocking shapes work well in patterning.

Central orientation: here, the interest is at the centre of a study, usually within a circular or square format.

S curve: this can be helpful to take your eye through a textile study or painting; landscape artists often use a river or path to create this effect, but the S curve can be equally important in abstract designs to create a path through the work.

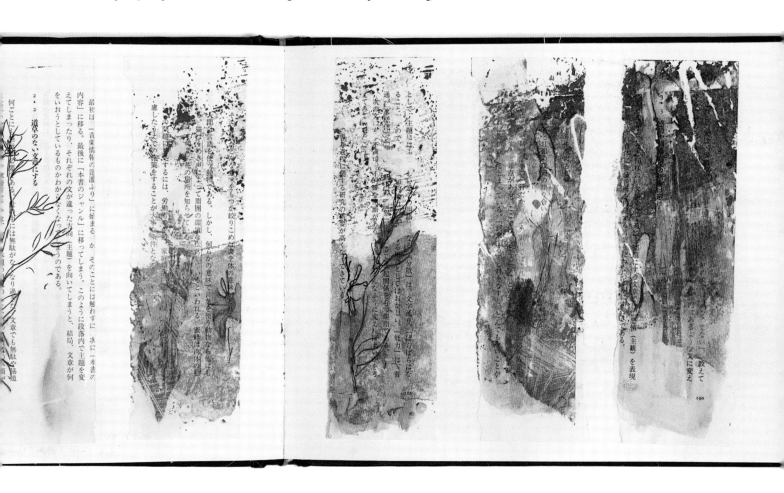

Design options

Given the basic elements of design, consider your response to composition. Find your own way into the subject. Each composition calls for a different solution and there are no sure-fire formulas. The more planning and experimenting you do at the beginning, the more likely you are to build a range of ideas that lead to sustained works and a successful finish. The 'happy accident' is welcome at times, but it's a rare event.

A useful design exercise is to create simple collages from a limited range of coloured and textured papers. These could be a combination of 'found' papers, taken from newspapers and magazines, and papers you have stained or painted yourself. Create a minimum of four working samples, using the same paper sources in each of the designs. Remember the papers will have a front and back. Lay the cut and torn papers out before gluing them down. As you progress, themes or ideas may evolve to reinforce your concept.

- Introduce elements not commonly associated with the subject or invent an unusual juxtaposition: for example, change a peaceful landscape by using hard edges, violent colours or jarring contrasts.
- Start with a collection of found materials from a single journey or collected from one situation, such as a visit to a museum.
- Look at light and dark spaces in relation to your subject.
- Plan a distinctive colour scheme. Consider hot colours, cool restful colours and contrasts in colour.
- Consider dynamic angles and shapes, experimenting with large shapes and intricate patterns.
- Look at variations of design format. Try making your subject interact with the edges or form interesting negative areas.
- Develop confidence in design. Make big shapes by combining several smaller shapes. Arrange lights and darks into an effective pattern.

Carefully choose the surfaces and papers your feel would best suit your ideas. Use your sketchbook to try different plans.

Left: Collection of found and printed papers for a collage exercise using limited papers and colours.

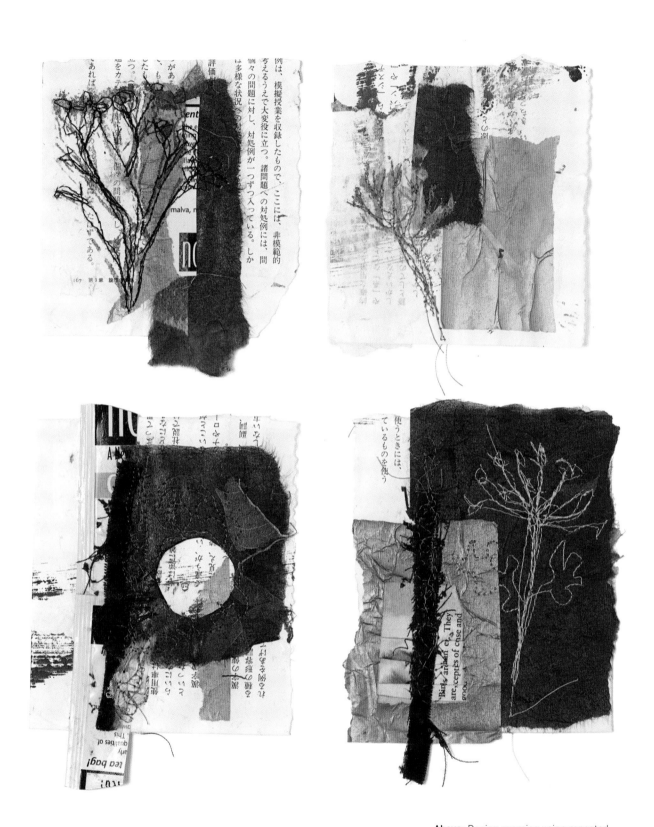

Above: Design exercise using repeated shapes, colours and themes.

Notan: positive and negative shapes for design

Notan is a Japanese design concept involving the play and placement of light and dark next to each other as a part of art and imagery. It looks at how positive and negative shapes create interest on a flat surface. These studies are traditionally presented in paint, ink and cut-paper designs, but the concept is a useful aid for textile art design.

Looking at the principle of notan, you can create interesting symmetrical designs, using the positive and negative spaces from paper cut-outs to create mirrored images.

Method
1. Take dark-coloured paper squares and cut from the outside edge.
2. The cut papers are pasted down to form a pattern. The 'negative' cut-away sections are flipped over and touch the original square.
3. The pattern can be copied and repeated, using a photocopier or scanned and copied in your computer.

You can extend this idea of the repeat by looking at interesting found objects to use as templates for a repeated design. Any object with a flat base can be traced to make a card template. The design shown below uses a simple bottle opener.

Opposite: Examples of paper cuts using the notan concept, with its positive and negative shapes.
Below: The outline of a bottle opener, copied and repeated.

If you get stuck...

Keeping sketchbooks and journals, recording your ideas as you progress, will help with the general flow of ideas. It is a reflective process that acts to support the development of your pieces. However, if you feel stuck, there are a few basic questions you can ask yourself that may help:

- Is the work too busy and therefore confusing? Leaving some open areas allows for details to be seen.
- Are there problems with tone, the quality of light and dark within the work? Try half-closing your eyes or look at the piece reflected in a mirror, as this helps you to see the light and dark elements more clearly. Better still, take a photograph and look at the work in monochrome on your computer screen.
- Is there a focal point or centre of interest?
- Think of your design as a menu in which contrast, colour balance, variety and so on need to be balanced.
- Always look at your work against a clean background (not a dark wood table or the carpet on the floor).
- Try putting your work away for a short while. When you look at it again, you will see it with fresh eyes.
- If possible, get together with other makers for regular sessions and use this time to bring in pieces you want to discuss and collect feedback on.
- And if all else fails, cut the work up and reuse the pieces in new creations or in your sketchbook.

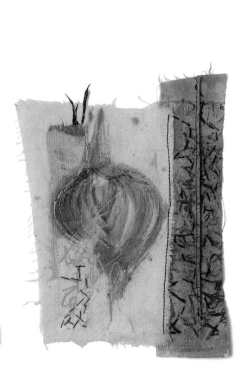

Above: *Red Onion* (detail). Stitch was added to a collage of rubbings, prints and cut-up papers.
Left: *Red Onion.* Stitched and printed fragments from waste materials.
Right: *Blue Flora.* Layered vintage fabrics, dyed and printed, with yellow stitch detail.

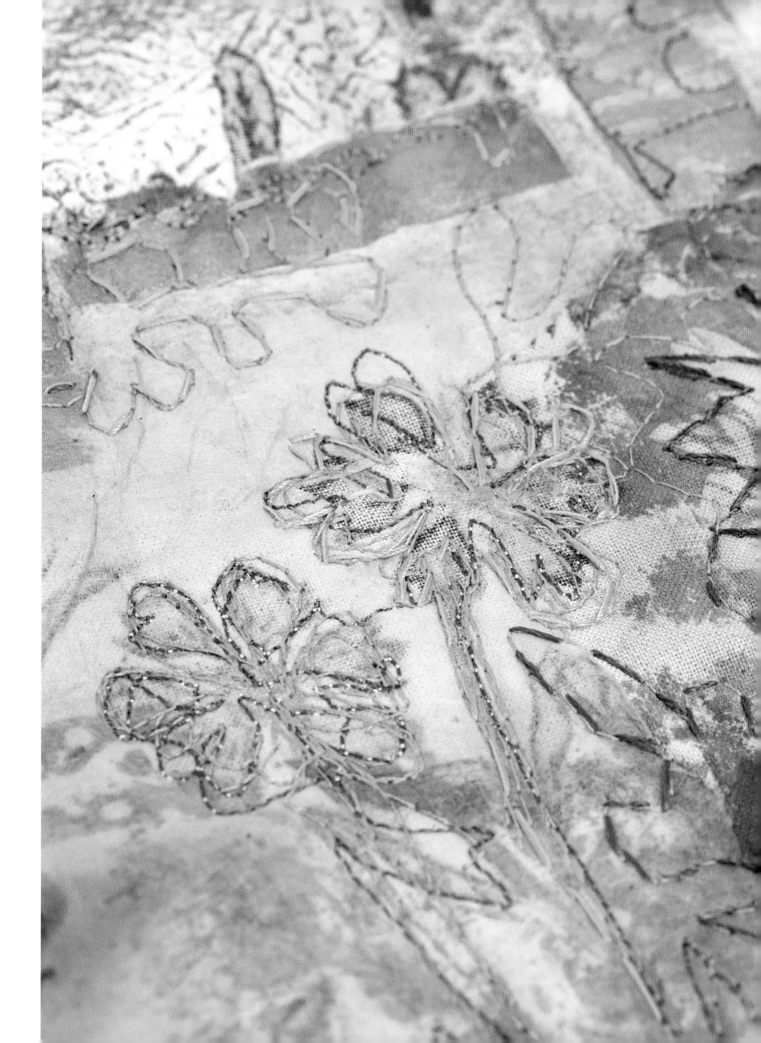

4 Sharing

The use of the 'found' in my work reflects and comments on the changes in our living needs that impact on the land, and specifically the flora and landscape of the southeast of England.

This approach, through looking at context and narrative, enables the creation of pieces which have relevance to given situations, audiences and locations and which are motivated by exchange with others as part of this process. A large part of my professional practice involves workshops with schools and communities and using 'what is there'. Natural and found materials are used to create land 'drawings' in outside spaces and collected waste is used to create textiles and three-dimensional pieces. Working with others can keep you open to new approaches in your own work as well as encouraging the investigation and development of ideas in the use of the found, and a relationship to the land around us. Not least, it provides a wonderful opportunity to share an exchange of found materials to work with on future projects.

Opposite and below: *Red Rain*. Installation with teabags and red threads. Opposite: detail of the work at the Riverhouse Gallery, Walton-on-Thames. Below: installed in the stairwell of a building at offices in King's Hill, Kent.

Community and education

Educational work carries its own rewards, not least the possibility of starting people on their own creative journeys, regardless of age or ability. Most of the projects I have undertaken using found materials have looked at the world around us and encouraged participants to focus on what interests them, whether it be the built or the natural environment.

Taking urban/nature as a theme, for example, look at the way plant life finds its way into our built environment – the buildings and machinery of everyday life. Investigate subject matter in the surroundings which reflects this theme, such as a derelict building or plants growing in cracked paving, and encourage participants to collect material and take photographs, as well as making sketches and collages to develop their ideas.

Work evolving from this process can be hung as a group piece; each person making their own urban/nature 'strips', combining paper and fabric. Throughout the working process, discuss design elements and how these pieces may come together as a whole. Look at other modular forms for inspiration, such as patterns in pavements or window shapes, as well as the work of other artists who make use of pattern.

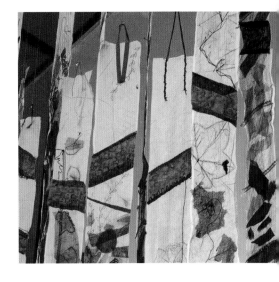

Above: *Recycled By Design.* Installation created with students at Woking College, Surrey.
Below: *Growing Garden.* Dyed paper and stitch installation created with students at Bradbourne School, Kent.

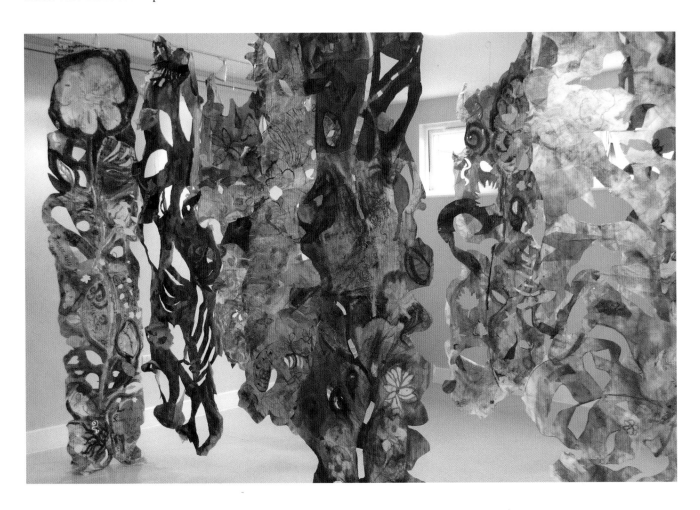

Working outside with found materials offers its own challenges for the textile artist. I have worked in a variety of spaces where creating patterns through layering and binding the contrasting materials I find around me is a natural progression for the textile artist and one that can provide a broad creative scope. Working with groups of children and adults in woods, on beaches and in other outside spaces, we use locally found, mostly natural, materials. This opens up the possibility of creating a body of work that travels through several seasons and reflects the changes found in them. Participants explore and learn about the natural environment and can compare and contrast this with their own school or college setting. This helps to provide an understanding of the environments in which they find themselves, both rural and urban. Looking at the work of other artists, such as the organic 'drawings' and 'sculptures' of Andy Goldsworthy or Richard Long's massive land installations, encourages interpretation and experimentation.

You need to think about the external environment and the available materials. Seasons greatly affect the colour choices. Patterns and rhythms in work can become more obvious with bright autumn colours. On windy days, leaves can be pegged into the ground, as if you were making a rag rug, to form a carpet of colours. Children, in particular, can be incredibly imaginative and perceptive and, when so many are driven from place to place or have little opportunity to play in the woods, they often relish the chance to work outside. On a project at King's Wood, near Ashford in Kent, children used forest materials, leaves, flints, chalk and charcoal to make sculptural reliefs. The opportunity to work in a novel way proved of benefit to the children, as noted in this extract from a conversation between the education officer and a teaching assistant:

Right: Paper threading on branches, King's Wood, Kent. Part of the Stour Valley Arts Project.

TA:

'Children that I've noticed don't particularly engage in the classroom have worked diligently the whole time, collecting materials, talking to each other, moving around safely, working so hard, working together as a team. And children that wouldn't usually be classed as leaders in the classroom, academically, are leading the projects that they are working on; giving instructions.'

EO:

'Do you think that [their response] is because some of the students are physical learners?'

TA:

'Absolutely. By engaging with the materials; touching them, feeling them, even the smells, I think everything is motivating them in a different way than when they're in the classroom.'

Transcript from ipod recording of a discussion with one of the teaching assistants, Lucy Medhurst, Education, Stour Valley Arts.

Below: *Fern Circle.* Installation at King's Wood, Kent. Part of the Stour Valley Arts Project.

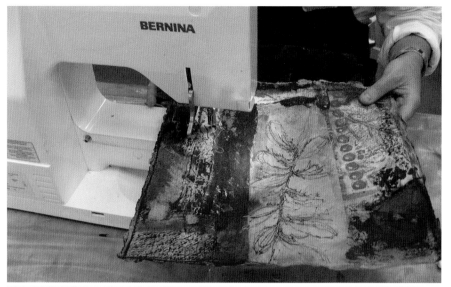

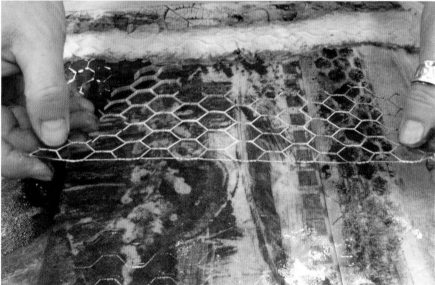

Part of the challenge of working with other professionals and enthusiasts is the opportunity to share resources and exchange and swap found materials. A good starting point is to use the images, patterns and textures you see in the immediate environment as a source of finds. The building and grounds of the college of West Dean, which houses a fantastic collection of Surrealistic art and other objects, is a great design source.

I encourage students on my courses to start their own visual diary, creating sketches and developing ideas in unconventional ways. A primary focus of their work is collecting materials to work with, while all the time referencing the environment of West Dean or their own design sources. Often, workshops start with a quick trawl through waste bins, picking out materials that tutors and students have disposed of, or a walk outside to collect natural objects to make drawings with or to search for surfaces from which to take a rubbing. The challenge can also be in the exchange: pooling found materials, which are later redistributed as people work. This acts as a spur to creative activity, as individuals seek to find a way of working with a material not of their choosing.

Top: Free-machining a collage at West Dean Summer School (Jenny Thomas).
Above: Printing with wire at West Dean Summer School (Jane Adams).

Commissions and collaborations

Often, the space or context itself will provide the framework or stimulus for new works. This can certainly be true for commissioned work or collaborations to be set in the public context. Indeed, it is usually inevitable that any exhibition or commission funded through the Arts Council, the National Lottery or other funding bodies, will require some public or community involvement. For the artist who likes to collect, this interaction can provide all kinds of interesting resources for reuse. In fact, if we include the finding and sharing of skills, the use of the found need not limit itself to physical materials alone.

Poppies, set in the Rochester Cathedral crypt, bought together participants from the local community of the Medway towns. Created as part of *Traces* (an exhibition of my work held in Rochester in 2007), this installation used poppies gathered by council workers from Remembrance Sunday services, together with paper waste from a local mill, and employed the waste fabrics and wonderful skills of the ecclesiastical embroiderers at the cathedral for the stitch work. Linking with the annual Big Draw event in October, community participants looked at symbols, images, graffiti and rubbings from the crypt and the high street, stitching and drawing images that reflected cultural patterns taken from local textiles and buildings. The placing of the work in the context of the crypt and the timing of its presentation to coincide with Remembrance Sunday meant that it acted as a fitting tribute to the fallen.

'Unused' spaces and unusual situations can provide an interesting platform for sharing. An office space waiting for a tenant proved to be a perfect place in which to install *Fen*, at Kings Hill in Kent (see picture on page 120). Supported by a national organization, Arts and Business, and the Kings Hill Art Project, the piece related to the idea of bringing green space into the office environment and used waste office paper and fabric that had been buried to age the surfaces. Office workers moved their hands through *Red Rain*, an installation piece, almost from the minute it was placed on the stairwell. Constructed from old teabags, it is a reminder of the refreshing qualities of a good cup of tea: see picture on page 113.

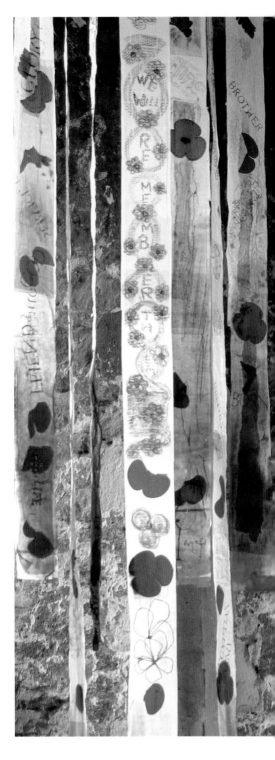

Above: *Poppies.* Installation using poppies from old Remembrance Day wreaths. Community collaboration in Rochester Cathedral, Kent.

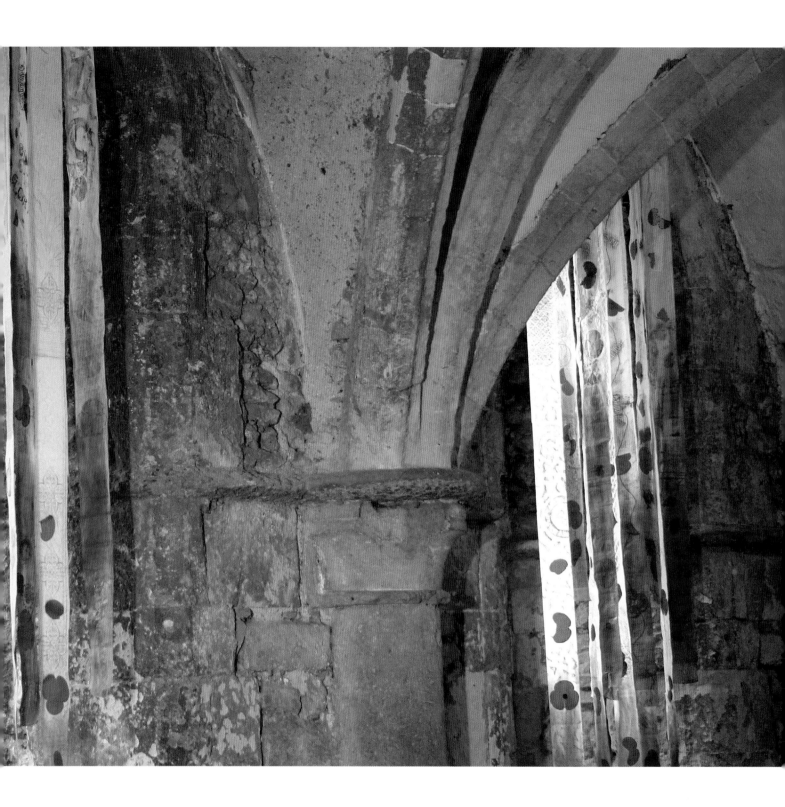

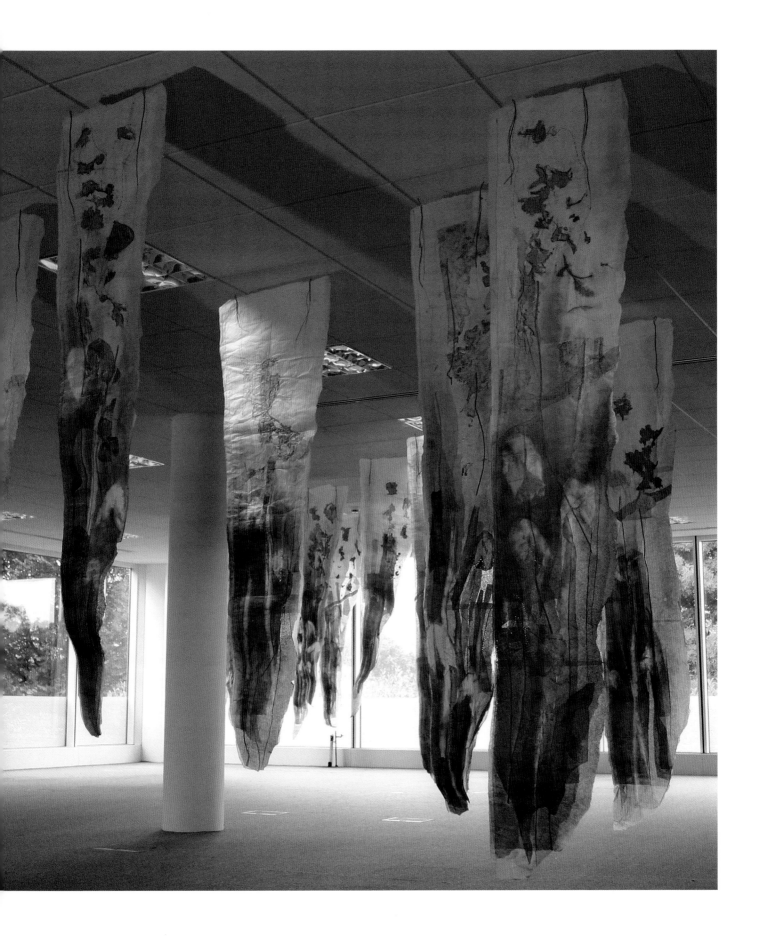

Gathering images, making drawings and taking photographs, as well as collecting original materials (fabrics, found objects, pages from old books or maps) can be a good way to start a commissioned piece that has relevance to a given context or community. Many of my public commissions engage with the local community in precisely this way. Prior to starting a textile, I will spend a few days speaking to people, informally discussing my work and inviting the contribution of found materials and images that may can be used to help with the creation of work.

A commission at the Princess Royal University Hospital, near Orpington, Kent, reflects this process. The nursing and administration staff found some old black-and-white images of nursing at the hospital, dating from the early 1950s, which would complement more recent images of the building and surroundings. Using emulsion-transfer techniques and stitch, these were incorporated into the hanging. Patients and visitors donated old fabrics and I gathered plant images and materials while walking around the grounds of the hospital. This process not only stimulates ideas for my creative journey with the commission process, but also enables others to contribute and gain a sense of ownership over the resulting piece of work. Of course, there are practical considerations, such as fire retarding and framing, to take on board, but when creating a work for a public space, that sense of ownership is a most important priority. My feeling is that it is best achieved by encouraging others to find the images and objects which have meaning for them and which can be identified and appreciated in the completed textile.

Opposite: *Fen.* Installation in an empty office space at Kings Hill, Kent.
Below: *Place In Time.* Piece displayed at Princess Royal University Hospital, Kent.

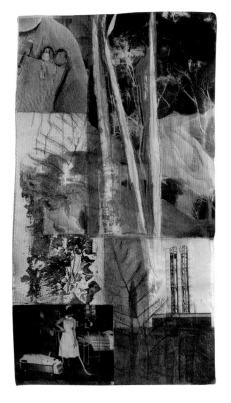
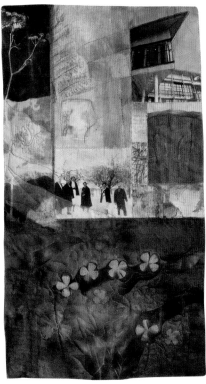
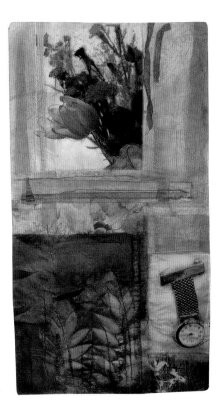

'Resonant Textiles'

For modern makers to be creative, they need to continue to be challenged. Using found materials involves a complex mixture of motivations, which are as likely to be ethical, economic and practical as creative. As a stimulus for ideas, being given found materials (as opposed to sourcing your own) and working with others can create new methods and approaches to working.

Fellow textile artist Anne Kelly and I make the time to come together on a monthly basis to exchange materials and ideas and learn from one another as we work. We are both 'magpies' and regularly visit charity shops and collect things on our journeys, which we then save for each other to exchange and use in our experiments. Using fragments of stitched and printed materials from our own work, as well as interesting fabric and paper scraps from a shared resource, we find that we use each other's finds differently and with a fresh approach. We both teach and, as part of this process, we incorporate the ideas and techniques that evolve from these collaborations into our work and teaching. Our working methods and techniques directly influence the development and outcome of our textile pieces.

As part of a collaborative process, we:

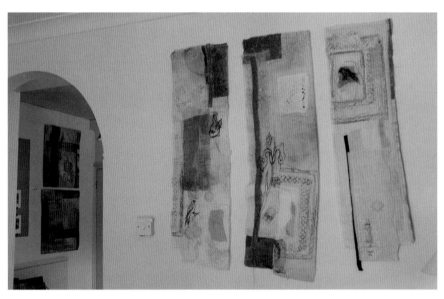

Above: *Iris and Birds*. This work arose from an exchange of waste fabrics with artist Anne Kelly.

- Hold workshops in each other's studios as a means to cross-fertilize ideas and practices and to counteract what can be the artist's greatest enemy at times – isolation.
- Share ideas in studio workshop days, and draw, visit exhibitions, gather resources and experiment with techniques together.
- Cross-exchange ideas via emails or letters, share found materials and swap ideas.
- Reflect on the collaborative process, noting what happens during our exchanges and how it informs our working process.
- Exhibit our work as a means to discuss and share with others what we learn from this process of using 'the found'.

This process of working has also made us more aware of the value of monitoring waste and recycling and of how we use found materials, both in our own work and in our teaching. We share our experiences and support each other with ideas and constructive criticism. We call this process 'Resonant Textiles', marking the journey of the 'found materials' we use as they develop into new works.

Conclusion

'Chance is the greatest creative force that can happen', according to Leo Sewell, a Philadelphia-based artist. It is the act of serendipity, of chance, that can serve to give us the creative start. Some birds, magpies amongst them, use shiny things they find to decorate their nests. The idea of creating something from virtually nothing, or nothing of real value, and the sense that a found object is simply a free gift from the world, provides the textile artist with a whole new vocabulary as part of the making process. Aside from the environmental or green imperative to reuse items or objects that might be otherwise disposed of, found objects may be put on a shelf and treated as works of art in themselves, as well as providing inspiration for the artist.

The process of making and transforming findings is informed by our creative relationship with materials. How we look at, think, feel and use the objects and materials we find for our own expression in fabric, mixed-media and stitch is up to us. This book gives you somewhere to start, based on my own practice and my work with others. Look around you and use what you find, both as a stimulus for ideas and as a resource or material for use. You really do not have to look beyond your own footsteps.

Below: *Fairy Tale Boxes* (detail). See page 74 for the complete piece.

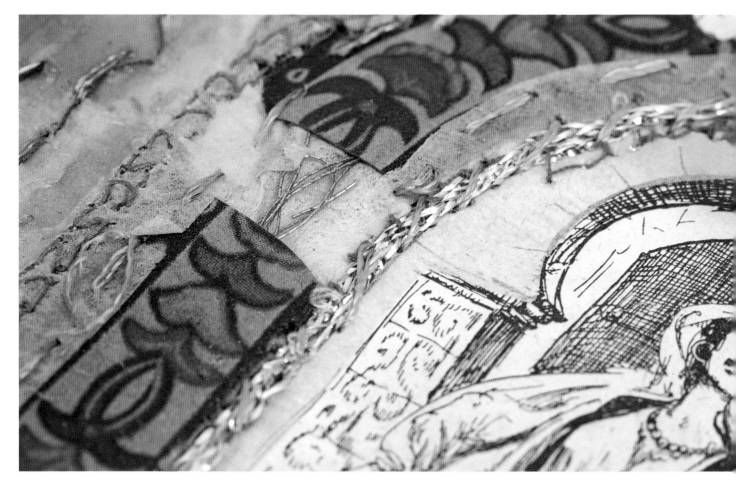

Suppliers

UK

Papers

Falkiners Fine Papers Ltd
76 Southampton Row
London WC1B 4AR
Tel: 0207 831 1151
www.falkiners.com

The Paper Shed
March House
Tollerton
York Y06 2EG

Textiles

Fibrecrafts
Old Portsmouth Road
Peasmarsh
Guildford
Surrey
GU3 1LZ
www.fibrecrafts.com

Rainbow Silks
6 Wheelers Yard
High Street
Great Missenden
Buckinghamshire
HP16 OAL
Tel: 01494 862 111
www.rainbowsilks.co.uk

Whaleys (Bradford) Ltd
Harris Court
Great Horton
Bradford
West Yorkshire
BD7 4EQ
Tel: 01274 576 718
www.whaleys-bradford.ltd.uk

Winifred Cottage
17 Elms Road
Fleet
Hampshire
GU51 3EG
Tel: 01252 617 667
www.winifredcottage.co.uk

Cowslip Workshops
Newhouse Farm
St Stephens
Launceston
Cornwall
PL15 8JX
Tel: 01566 772 654
www.cowslipworkshops.com

Wolfin Textiles Ltd
1A Neptune Road
Harrow, Middlesex
HA1 4HY
Tel: 020 8427 7429
www.wolfintextiles.co.uk

General art supplies

Art Van Go
The Studios
1 Stevenage Road
Knebworth
Hertfordshire
SG3 6AN
Tel: 01438 814 946
www.artvango.co.uk

Colourcraft Ltd
Unit 5
555 Carlisle Street
Sheffield
S4 8DT
Tel: 0114 242 1431
www.colourcraftltd.com

Great Art
1 Nether Street
Alton, Hampshire
GU34 1EA
Tel: 01420 593 333
www.greatart.co.uk

USA and Canada

Pro Chemical and Dye, Inc
Tel: 800 228 9393
www.prochemical.com

Dharma Trading Company
Tel: 800 542 5227
www.dharmatrading.com

Quilting Arts
www.quiltingarts.com

Australia

The Thread Studio
www.thethreadstudio.com

Australian Forum for Textile Artists
www.tafta.org.au

Fibre Arts Australia
www.fibrearts.com.au

General suppliers

- Explore your local hardware and DIY shops for paint, glues, fittings and equipment.
- Art and hobby shops.
- Supermarkets, charity and second-hand shops.

Bibliography

Burall, Paul. *Green Design*. Design Council, 1991.

Craftspace. *New Alchemists: Recycling* (exhibition catalogue), 1996.

Digby, John and Joan. *The Collage Handbook*. Thames and Hudson, 1985.

Elinor, Gillian. *Women and Craft*. Virago Press, 1987.

Greenlees, Kay. *Creating Sketchbooks for Embroiderers and Textile Artists*. Batsford, 2003.

Laury, Jean Ray. *Imagery on Fabric*. C & T Publishing, 1997.

Papenek, Victor. *The Green Imperative: Ecology and Ethics in Design and Architecture*. Thames and Hudson, 1995.

Parker, Rozsika. *The Subversive Stitch: Embroidery and the Making of the Feminine*. Women's Press, 1984.

Pearce, Amanda. *The Art and Craft of Collage*. Mitchell Beazley, 1997.

Shannon, Faith. *Paper Pleasures* (reissued as the *Art and Craft of Paper*). Mitchell Beazley, 1988.

Scott, Jac. *Textile Perspectives in Mixed-Media Sculpture*. The Crowood Press, 2003.

Thomas, Jane and Paul Jackson. *On Paper: New Paper Art*. Merrell, 2001.

Below: Envelope used to package work to be sent to an art exhibition. Machine- and handstitched.

Websites and groups

www.textilearts.net
An excellent website with links to embroidery groups, suppliers and exhibitions.

www.axisweb.org
Artists in general, easy to use.

www.workshopontheweb.com
Internet magazine for textile artists.

www.texi.org
The Textile Institute, a worldwide organization.

www.quiltersguild.org.uk
The Quilters' Guild of the UK.

www.embroiderersguild.com
The Embroiderers' Guild.

www.canadianquilter.com
Canadian Quilters' Association.

www.62group.org.uk
Contemporary British textile arts group.

www.casholmes.textilearts.net
www.axisweb.org/artist/casholmes
www.casholmes.pwp.blueyonder.co.uk

Artists featured in this book:
Penny Burnfield
www.textilestudygroup.co.uk

Anne Kelly
www.annekellytextiles.com

Sue Pritchard
www.sues-stuff.co.uk

Susan Cutts
www.susancutts.com

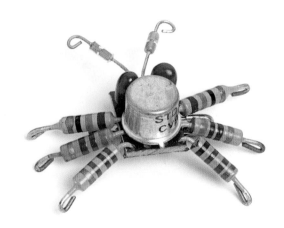

Acknowledgements

The author would like to thank the following people and organizations: Staff and students at West Dean College, (www.westdean.org.uk) for use of images and advice; students who have attended workshops in the UK and abroad who have kindly allowed me to photograph them at work; schools and organizations listed in the text, with particular thanks to Arts Council England, who supported community collaborations with the Medway Arts Development team, and Bilston Craft Gallery as part of the *Traces* and *Transitions* touring exhibitions; friends and family for feedback and advice.

Picture credits: All pictures by Michael Wicks, except the following: Bodybarn.com (pages 75 and 91); Colourcrafts Ltd (page 10); Derek Hodge (pages 56, 84 and 121); Cas Holmes (pages 23, 24, 25, 26, 27, 28 (bottom), 32, 33, 36, 40 (right), 41 (left), 42, 44 (top and bottom), 52, 57, 66, 67 (bottom two), 70 (bottom), 76, 77, 78, 85, 95, 96, 97, 103 (top), 108, 109, 112, 113, 114, 115, 116, 117, 118, 119, 120 and 122; Simon Margetson (page 87); Nick O'Neill (page 86); Chris Smart (pages 6, 11 and 89).

Below: Sketchbook with prints from lace.

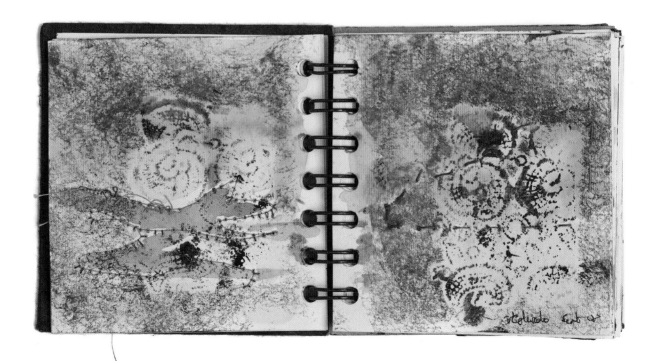

Index